Learn to Paint

Landscapes in Pastel

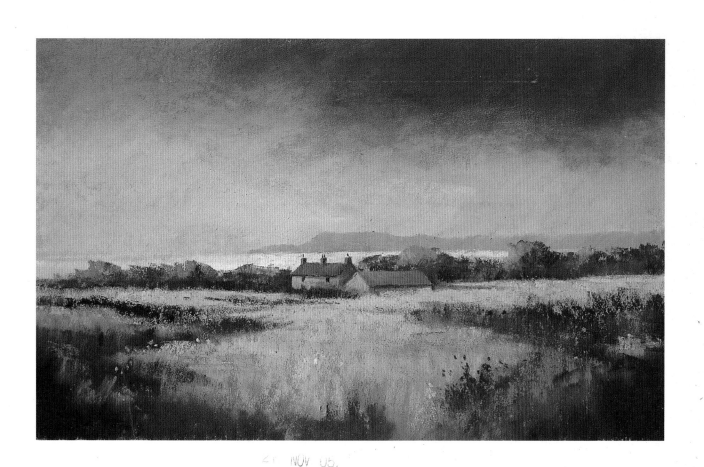

JENNY KEAL

Dedication
**To David, whose faith in me never falters even when mine does, and who
provides encouragement beyond the call of duty.**

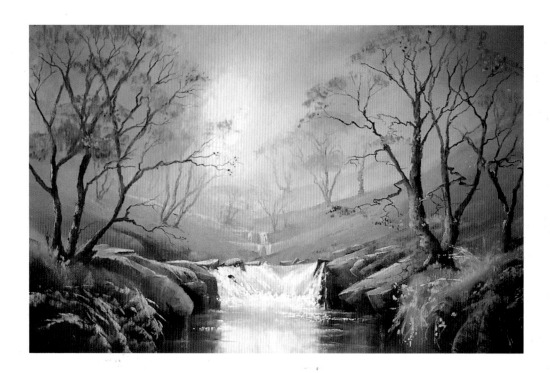

First published in 2003 by
Collins, an imprint of
HarperCollins*Publishers*
77-85 Fulham Palace Road
Hammersmith, London W6 8JB

The Collins website address is:
www.collins.co.uk

Collins is a registered trademark of HarperCollins Publishers Limited.

04 06 08 10 09 07 05 03
2 4 6 8 10 9 7 5 3 1

© Jenny Keal, 2003

A catalogue record for this book is available from the British Library.

Editor: Tess Szymanis
Designers: Liz Joseph and Penny Dawes
Photographer: Nigel Cheffers-Heard

ISBN 0 00 714385 0

Colour reproduction by Colourscan, Singapore
Printed and bound by Printing Express Ltd, Hong Kong

Previous page: **Coastal Farm near Whitby** 15 x 24 cm (6 x 9½ in)
This page: **Woodland Stream** 25 x 35 cm (10 x 14 in)
Opposite: **Marston, Norfolk** 25 x 25 cm (10 x 10 in)

Contents

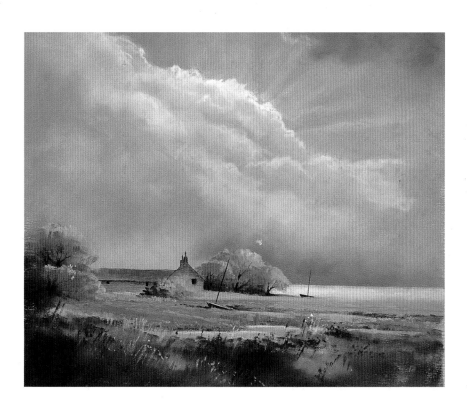

Portrait of an Artist

Jenny Keal has been interested in painting all her life. Art was her favourite subject at school, but she only took it up seriously once her two daughters were at school. She has always enjoyed drawing with a pencil and, like many amateur painters, she started painting with, what she thought, was the easiest medium – watercolour.

However, she soon discovered her mistake. She will always remember the smirk on the art-shop assistant's face when she said that she would start painting with watercolour because it is the easiest medium. After many years of unsatisfactory progress, a friend at her art club suggested using pastels. She was hooked immediately.

Jenny is fascinated by social history, vernacular architecture and cultural and domestic anthropology. This leads her to explore remote areas worldwide in pursuit of pieces of the past that have survived the scourge of development. Nothing excites her more than a remote upland farm that is still occupied, with chickens round the door and bedsteads in the fence.

She believes that many people have a nostalgic view of the past, yearning for the elusive, simple life epitomized by Victorian

◀ Jenny Keal painting in her studio.

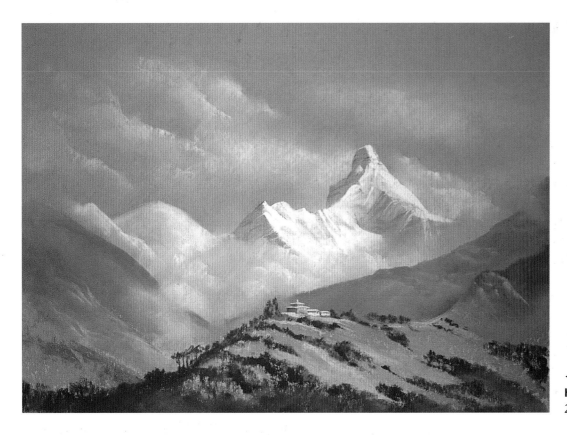

landscapes, and strive to recreate such a world in their paintings. Artists like Samuel Prout, Helen Allingham and Benjamin Williams Leader all created a record of the world they lived in, providing us with a glimpse of the past, however rose-tinted their glasses.

Jenny is a popular demonstrator at art societies, and runs her own courses and workshops on pastel painting. She writes articles for *Leisure Painter* magazine and has featured in the Welsh television series *Painting Wild Wales*. Her paintings are in collections worldwide.

Sources of inspiration

Jenny is married to well-known watercolour artist, author and adventurer, David Bellamy. For several years, David and Jenny have taken groups of painters on trips to exciting and stimulating locations all over the world, especially remote mountain regions.

Their mutual love of the landscape, travel and exploration has resulted in some very precious moments. Trekking through the Olkarien Gorge in Tanzania with a Maasai warrior as a guide; reaching the 'gateway of the sun' on the Inca trail in Peru for their first view of Machu Picchu; and being surrounded by delightful Nepalese children whenever they stopped to sketch in the Himalayas.

Jenny always keeps a journal whilst travelling. It includes sketches and paintings of local architecture together with local people at work, play or looking after their animals. This journal includes a diary of her trip, which include descriptions of local crafts and customs, historical notes, myths, legends and beliefs of the people. These journals are invaluable when she returns home and starts to work on her paintings. They help her to recreate her emotional response to the subjects.

She finds sketching an excellent way of breaking down barriers with locals and learning about their culture. Contrary to the fear that many artists feel about attracting attention, she welcomes the opportunity to connect with people and finds it an enriching experience. Having achieved that rapport, she can then happily continue sketching.

Painting Landscapes in Pastel

The seductive, rich colours and the subtle, soft tones of pastel captivated me from my first encounter with them. After struggling with watercolour for many years I was delighted with the effects I could achieve right from the start.

The ability to use light colours over dark allows you to develop a painting. You can then add highlights and lighter tones at the end. The interplay of contrast and harmony makes a painting work, so revel in those rich dark areas of your painting because they will fill your work with drama. You can exploit the attributes of pastel to portray many moods of nature, from morning mist on a silent lake to the crash of surf against jagged rocks.

Skies offer endless possibilities for the pastel painter. Whether you want to portray wind-torn clouds or a serene summer day, the medium lends itself to realistic renditions. The choice of soft or hard-edged clouds is simply a matter of deciding whether to gently blend with a finger, or to leave the original pastel mark sharply etched. An approaching storm – using purple and blue greys; a spectacular sunset on a beach – using yellows, oranges and reds; or even a moonlit sky – using the darkest blue with silver edged clouds – are all in your box of pastels.

Creating a sense of recession, so important in landscape painting, is where the medium of pastel excels. From the ease with which one can soften distant hills or trees, to the way the tones and colours of pastels are organized when you purchase them, the work is almost done for you. With most other

▼ **Nantyffin**
18 x 29 cm (7 x 11½ in)
Rich colours help to give pastel paintings vibrancy and impact.

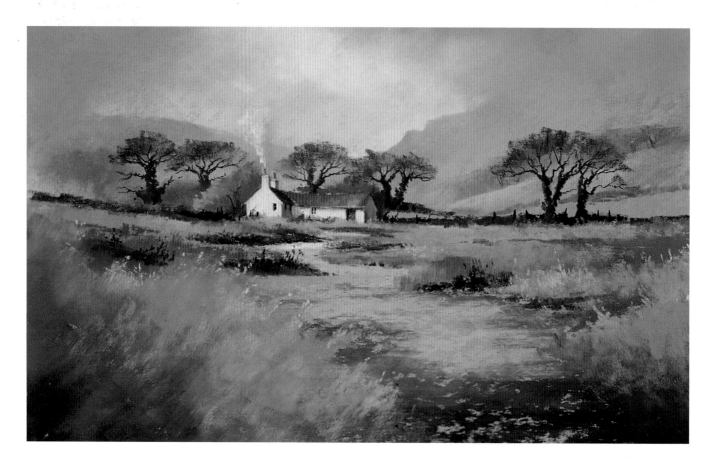

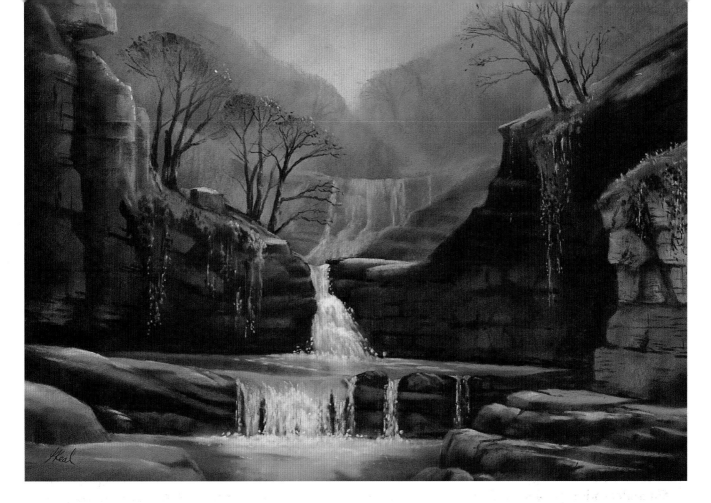

mediums you have to mix your own tones and colours. Pastels are sold in a range of tones for each hue, which means that understanding colour and tone, one of the most difficult concepts for the beginner artist, is simplified.

Advantages of pastel

Opportunities for changing your painting as you progress are unlimited. You can rectify a mistake, clarify an ambiguous passage or even change your mind about the composition. When you realize that nothing is carved in stone, the confidence this grants will liberate you to become more experimental with the marks you make.

It is comforting to know that the marks you make will not fade, as with watercolour when it dries. Pastel will not run into other colours or form ugly runbacks and, providing you do not drag anything across the surface, it stays where you put it.

The myth that pastel is not as permanent as other mediums must surely now be dispelled. Once your work is securely framed there is no need to fear that it will deteriorate in any way. The resemblance to children's chalks may explain why this medium is sometimes not taken seriously, but pastel has been used by some of the world's most notable old masters. You could not, in all honesty, look at the work of Degas and not believe in its integrity.

If you have been painting unsatisfactory landscapes for years in your usual medium, have a go with pastels. You will be converted, I am sure.

▲ **Scwd Isaf Clungwyn**
33 x 43 cm (13 x 17 in)
An eight-year-old boy once asked me if a dragon lived in this painting. I could not have asked for a better compliment.

Use pastel to develop your own style and let your personality shine through.

Materials and Equipment

Pastels are a made from a combination of pigment, chalk and china clay bound together into a convenient stick of colour using a binding agent.

Types of pastel

There are three basic types of pastel stick: soft pastel, hard pastel and oil pastel. There are also pastel pencils, which are ideal for detailed work. This book concentrates on using soft pastels as they are the most suitable for painting landscapes.

Soft pastels

There are numerous brands of soft pastel on the market. All are suitable for landscape painting and, as a rule, the more expensive brands are easier to use and have a wider colour range. Most soft pastels come in round sticks, but different brands vary in width and length. Each hue, or colour, normally comes in a range of tones.

Some brands of pastel are soft and creamy, while others are more powdery. Some sticks hold together well but others crumble quite easily, especially the paler tones. This is because the lighter tones contain more chalk than the darker tones, which have more pure pigment. You will find that the better quality pastels are more consistent through the tonal range.

It is tempting to pick all the luscious bright colours when buying your first set of pastels. However, for landscape painting, it is more useful to have a wide range of greys, with just

◀ A selection of soft pastels and pastel pencils.

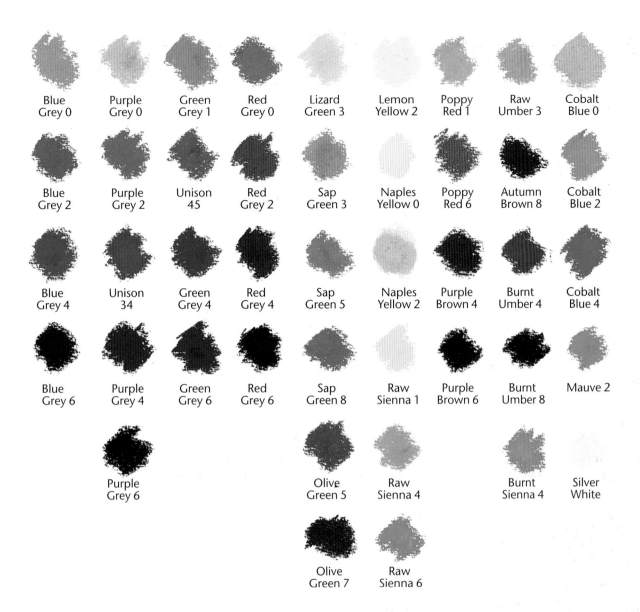

Blue Grey 0	Purple Grey 0	Green Grey 1	Red Grey 0	Lizard Green 3	Lemon Yellow 2	Poppy Red 1	Raw Umber 3	Cobalt Blue 0
Blue Grey 2	Purple Grey 2	Unison 45	Red Grey 2	Sap Green 3	Naples Yellow 0	Poppy Red 6	Autumn Brown 8	Cobalt Blue 2
Blue Grey 4	Unison 34	Green Grey 4	Red Grey 4	Sap Green 5	Naples Yellow 2	Purple Brown 4	Burnt Umber 4	Cobalt Blue 4
Blue Grey 6	Purple Grey 4	Green Grey 6	Red Grey 6	Sap Green 8	Raw Sienna 1	Purple Brown 6	Burnt Umber 8	Mauve 2
Purple Grey 6				Olive Green 5	Raw Sienna 4		Burnt Sienna 4	Silver White
				Olive Green 7	Raw Sienna 6			

a few brighter colours for highlights. Some rich dark colours are also useful to create strong contrasts. For this reason I recommend choosing your own colours rather than buying a boxed set.

Bear in mind that you cannot mix two colours together to get a third, as with other mediums. Within each colour, or hue, there is a choice of several tints, ranging from very pale to very dark. A basic starter kit can consist of just seven or eight colours, each with a range of tints, or tones.

Hard pastels

If in doubt when buying pastels, check their softness and blendability on a scrap of paper before purchasing them. Some brands may look like soft pastels but are, in fact, quite hard and difficult to blend. Avoid these for landscape painting as they make the process rather hard work.

Oil pastels

These pastels have a waxy consistency and generally come in strong, bright colours. There are only a few subtle greys in the range, which makes them less suitable than soft pastels for landscape painting. To blend them, you also need a solvent to break down the binding agent.

Pastel pencils

A well-sharpened pastel pencil will enable you to make the most delicate of marks. There

▲ This is the basic landscape set of pastel colours that I recommend.

9

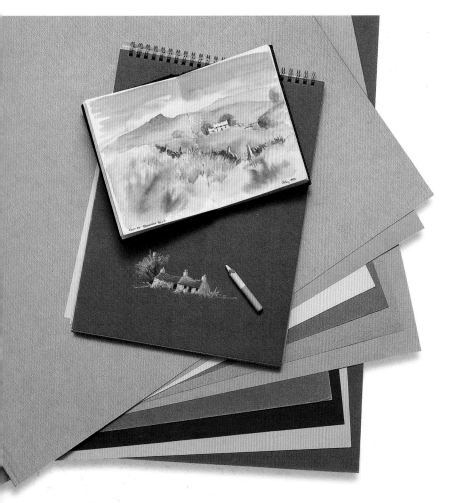

▲ A variety of surfaces suitable for pastel painting and drawing.

you will find a mail order source of fine abrasive surfaces in sheets big enough for quite large paintings.

Using an abrasive surface for your pastels will give your colours more vibrancy and strength. Creating fine detail with pastel pencils and colour shapers is also more effective on these surfaces. Pastels painted on smooth paper can have a rather dusty look, and it is more difficult to achieve fine detail. Experiment with several types of surface to find the one that suits you best.

Pastel papers come in a wide range of colours, so if you want to leave some of the paper showing, or vignette the painting, you can choose the tint of the paper to complement your work. If you find a white surface with a good tooth, you could do an underpainting with watercolour or acrylic to provide a background colour.

Other items

Colour shapers are rubber-tipped tools that come in various shapes and widths, and are useful for manipulating pastel once it is on your surface. You can use them to tidy up a line, blend small, intricate areas, or even move colour around your painting.

To prevent smudging, a fixative sprayed over your pastel painting reduces the risk of damage. Pastel fixative comes either in an aerosol or as a liquid in a bottle. If you buy a bottle of fixative, you will need a spray diffuser. Fixative works by wetting the pastel particles and fusing them onto the surface. As this process tends to subdue colours, it is

are several brands, which all vary in hardness. I prefer the softer type. However, some pastel pencils are so soft that they cannot be sharpened to a fine point, so test before you buy them. It is possible to buy a set of pastel pencils, but they normally consist of bright colours. Instead buy a white, a few greys and some muted pale colours. Several grades of charcoal pencil are also an essential part of my kit.

Surfaces

Pastel can be painted onto any surface that has a 'tooth', that is, one that is textured. There are various pastel papers on the market as well as several specialist pastel cards, sanded papers and boards. My personal preference is a fine abrasive surface. Most of the abrasive surfaces that I favour are not made specifically for the art market. However, by scanning through art magazines

Keep a damp rag or some wet-wipes handy to clean your hands.

better to build up layers and leave the final layer unfixed.

I always paint standing at an easel. This allows me to stand back periodically to judge how my painting is progressing. Keeping the painting in an upright position is good practice as it is all too easy, if the painting is in a horizontal position, to drag a sleeve across it and spoil all your hard work. If you prefer to sit, you can either use a stool at your easel or you can experiment with a table easel.

If you prefer to work in the open air, you will need a lightweight outdoor easel, which can be weighted down in windy conditions, and perhaps a stool. You will also need a drawing board, with your surface already taped down, and some sort of bag or rucksack to carry your materials.

Storing pastels

A wooden box, with compartments for different colours, is the traditional way to store pastels. A plastic box with compartments, designed to store nails or screws and available from your local DIY shop, is just as effective. Line the compartments with thin foam. Store your pastels in colour and tonal ranges because this helps to keep them clean. If you keep them all together, they will become coated with a uniform grey dust and you will be unable to distinguish one colour from another. If your pastels do become grubby, put them in a jar with some ground rice and give it a quick shake. Sieve away the rice and your pastels will be sparkling bright again.

▶ Here is a selection of the extra equipment needed besides the basic materials.

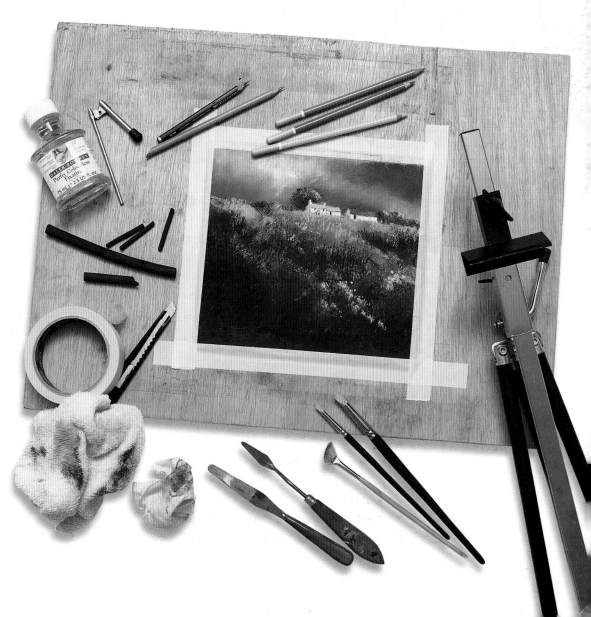

Pastel Techniques

Pastel is applied directly onto the painting with your fingers, eliminating the use of other tools and equipment. This encourages a spontaneous and expressive approach.

Start by removing the paper wrapper from your pastel stick before using it. Leaving the paper on will inhibit free and animated marks. However, if you are concerned about replacing the colour once it has lost its label, make a colour chart and note the colour next to the swatch.

Making your mark

There are several ways of applying pastel to a surface. For large passages of colour, such as sky, use a 5-7.5 cm (2-3 in) piece of pastel on its side to give rapid coverage. Where a more controlled mark is required, use the end of the pastel. Uneven dabs of colour using the end of a pastel are also very effective for foliage.

After a stick of pastel has been used to cover a large area it usually wears flat on one side. You can use the ridge at the edge of this flat side to create narrow, uneven lines, which are often more pleasing than a neatly drawn straight line.

◀ Using a pastel stick on its side to cover large areas.

◀ Using the edge of the pastel to create uneven lines.

▼ **Field Gate**
13 x 23 cm (5 x 9 in)
A simple exercise on pastel card to show you how few strokes it can take to make a painting.

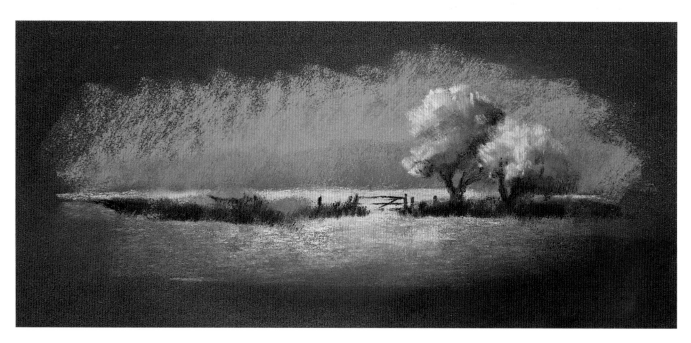

Blending

Using your finger to blend two tones or colours together creates a useful effect in landscapes. Use this technique to describe anything from cloudy skies to misty trees. A soft transition from one tone, or colour, to another will better describe distant features than hard edges, which grab your attention. Use your fingers, or the heel of your palm, to blend large areas easily. You could use a colour shaper for more intricate areas.

If you are painting on an abrasive surface, please be careful not to use your fingers to blend until there is plenty of pastel on the surface, otherwise your fingers will become sore and you could even draw blood.

A combination of areas softly blended together and some strongly defined features will help to create the illusion of recession in your painting. However, try not to blend everything because you will lose any textural effects. Most surfaces need to have the pastel worked in if you want to cover the grain. However, once this is done you can regain texture by working into the area again.

Texture

Scuffing pastel lightly across an already painted area can create an effect similar to a dry-brush technique in other mediums. Practise with different pressures on the pastel to see what results you can obtain. Use this technique for foreground fields or the haze of twigs on winter trees. The results will vary depending on the surface you are using. If you want this technique to work at its best, use fixative on the under layer and, when that has dried you can lightly drag a different colour across allowing some of the original colour to show through. Try to have some contrasting textures as well as tones in your painting.

Stippling and scraping

Foliage, flowers and undergrowth can be rendered by stippling uneven dots of colour

◀ Blending colours together will create a soft transition from one colour to another.

◀ Scuffing one colour over another will create texture. Fixing the first layer will produce a cleaner effect.

◀ Stippling involves dabbing the end of the pastel on the painting to create random marks.

◀ The scraping technique involves scraping flakes of pastel onto a horizontal surface and pressing them onto it with a palette knife.

over one another, using the point of the pastel and varying the sizes and shapes of the marks. Another technique is to lay your painting horizontally and scrape flakes of pastel onto the surface, pressing them into the grain with a palette knife. This technique creates more random marks.

Detail

It is difficult to achieve fine detail with a large stick of pastel. Sometimes you can obtain a fairly sharp point once the pastel has been worn down by rubbing it on its side. Using a knife to sharpen a stick of pastel to a fine point is wasteful. It is much easier to use a sharp pastel pencil or charcoal pencil for details such as fine branches, dry-stone walls and windows. By using several tints you can achieve the most intricate of details.

If your fingers are just too big to blend or shape a feature, for example a chimney pot, you could use a colour shaper. They come in various shapes and sizes, and a chisel-shaped one is ideal for blending tricky bits of detail. They can also be useful for tidying up edges or removing mistakes.

◄ A needle-sharp pastel pencil gives you all the control you need for detailed work.

◄ Use a colour shaper to tidy up edges or to move pigment around your surface.

Construct your set

Try to think of your painting as if it were a theatre set. Paint the main backdrop first, the sky and the far distance, and then move on to work on the middle ground and your focal point. Only when this is established should you finish the foreground. This method of

working will help to prevent your arm, cuff or sleeve from disturbing an already finished area.

Correcting mistakes

If something is in the wrong place, a colour does not work or an area has been overworked and looks muddy, simply brush

▼ **Broadhaven Beach** 15 x 29 cm (6 x 11 in) Construct your painting like a theatrical set. Start with the far distance, then the middle distance and finally the foreground.

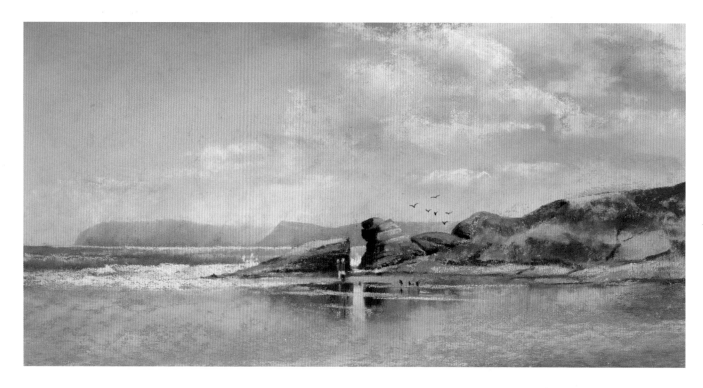

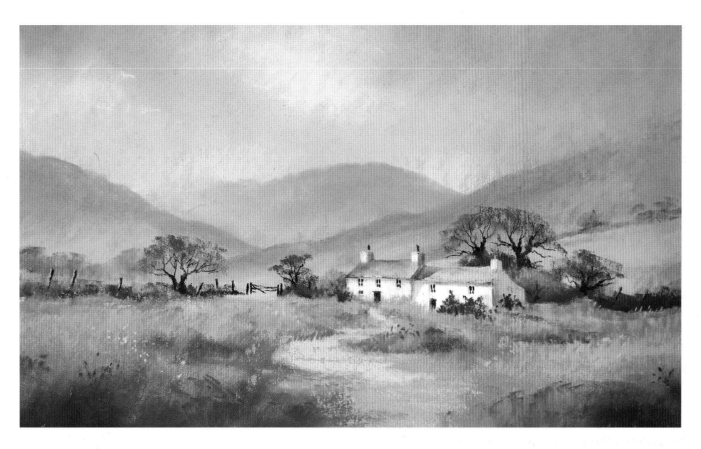

off the pastel and restate it. It is possible to overload your surface with too much pastel so that it just won't take any more. If you don't want to brush it off, try spraying it with fixative and, once this is dry, you can work into the grain again.

Controlling dust

Soft pastel creates dust and you need to take some precautions to minimize the mess and health risks. Working on an easel is the most important point. If you work flat on a desk, the loose pastel sits on the surface and you will be blowing dust into the air. However, if your work is positioned vertically, the dust will quietly drift down into the easel tray or onto the floor. Place an old towel on the floor beneath your easel. When you have finished painting, gather the towel up and carefully dispose of the dust outside.

Instead of blowing dust from your work, tap the board firmly to dislodge loose particles in a controlled way. You could wear a mask and, if you do not like the feel of the pastel on

your fingers, some disposable surgical gloves. I simply keep a damp rag handy to wipe the excess dust from my hands.

Storage and framing

When your painting is finished and you have taken it off the board, place it between a sheet of folded newspaper or clean smooth paper. Store the covered work flat, in a drawer, avoiding scraping things across the surface.

When you take your pastel to be framed, tap away any loose particles. Ask for a double, or triple mount, as this will create enough space between the glass and the surface to prevent the image transferring to the glass.

Be on the lookout for pleasing marks made accidentally – don't obliterate them.

▲ **Farm in the Hills**
15 x 30 cm (5 x 12 in)
Blending the pastel with your fingers helps to soften distant features, which creates a sense of recession.

Colour and Tone

Colour theory can be described as a science, rather than an art, because there are some hard and fast rules to follow. However, don't let that put you off as even a very basic understanding of how colour works will give you an advantage.

You can make or buy a colour wheel to show you which colours are complementary to one another, and which are primary or secondary, but the most useful thing to learn for landscape painting is colour temperature. Generally, warm colours, such as reds, oranges and yellows, come forward in a painting and cool colours, such as greens, blues and purples, will recede. However, there are warm and cool shades in all colours, so you need to be able to distinguish between warm and cool greens, for example.

In order to create a sense of the three dimensional, in a two-dimensional space, you have to create an illusion. For example, use a cool, blue grey for a distant tree and a bright, warm green for a foreground tree. There are other techniques to enhance this illusion, but colour temperature is one of the most fundamental. This does not mean that you cannot use warm colours for background features, or cool colours in the foreground, but you will have to use other techniques, such as tonal variation, to create recession.

◄ This is an artist's colour wheel. Red, blue and yellow are primary colours. Orange, green and purple are secondary colours. Notice how the complementary colours stand out strongly.

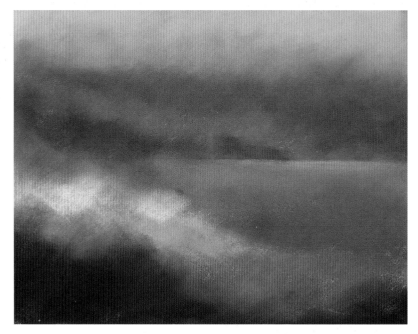

Colour harmony

Colours alongside each other on the colour wheel will create harmony, while those opposite each other will create contrast. To generate a feeling of mood in your scene use a very limited colour range or a combination of colours that are restful, or alternatively stimulating. As an exercise, scribble a series of different colour combinations to see which ones you find most effective.

Overseas colour

You may need some brighter hues for overseas paintings because the quality of the light gives vibrancy to colours. The sky is often a vivid cobalt blue and the buildings tend to have more colour in them, such as red pantile roofs and warm ochre walls. The greens of the foliage may also be more vibrant.

▲ It is possible to give the impression of a scene by only using colour, without any details at all. A sense of recession is achieved here by using just warm and cool colours.

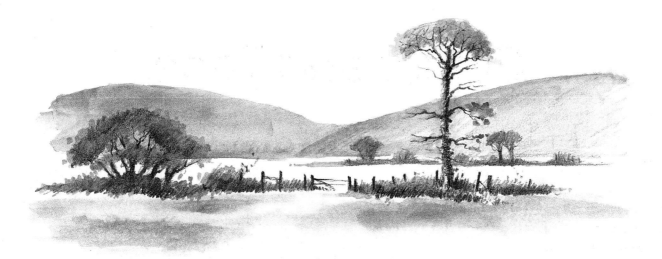

Tone

To understand tone look at a manufacturers' pastel colour chart. You will see that the colours are depicted in a range of light to dark shades (tones) within each colour. For example, if you take a white and a black pastel as the lightest and darkest tones, a wide range of greys can be produced in between. This tonal variety is also found within each colour. Some colours are light in tone, such as yellow, and some are dark, such as some of the blues.

Relating this information to the landscape, objects seen at a distance will normally be lighter in tone than those positioned close to you because of atmospheric conditions and the way light behaves.

The use of tone is also important when you want something to stand out boldly in your painting. This will generally be your focal point. For example, if you have a building with a light roof you will need something dark behind it to make it stand out or, vice versa, a dark roof against a light background.

To create that elusive illusion of space use a combination of tone and colour. Complementary colours, which sit opposite one another on the colour wheel, stand out boldly against one another. For example, blue and yellow are not only complementary to one another but are naturally dark and light in tone. They can be used to great effect to give impact in your painting.

▲ Distant objects are normally lighter in tone than those close to you.

▼ **Failing Light**
15 x 25 cm (6 x 10 in)
Using a limited range of colours will help you to understand tone. The warm colours in this scene give the painting a specific mood.

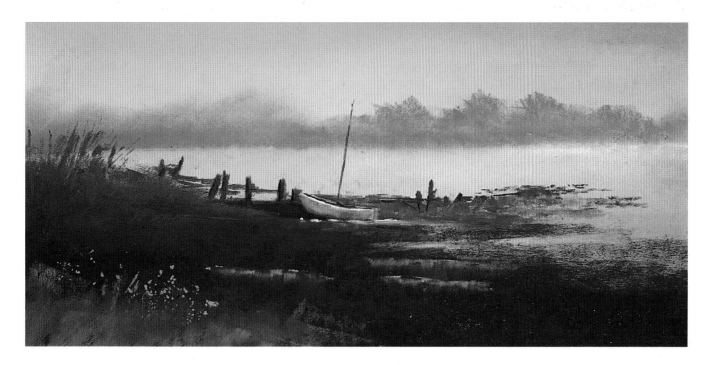

Sketching

To produce a landscape painting you will need source material. You can work from photographs, as many artists frequently do, but there is no substitute for the real thing. Getting out into the countryside, feeling the warmth of the sunshine, the bite of the wind or the smell of the sea air as you approach the coast will not only lift your spirits, but will inspire your painting.

What excites you?

Initially this might seem a bit overwhelming as there are so many sketching possibilities. Where do you start? As you travel around your own neighbourhood, or on days out in the countryside, notice what it is that excites you and makes you want to paint. Is it a dilapidated old building with shapely trees behind it, or perfect reflections at the edge of a lake? It might be something as simple as an old bit of fencing and a puddle. It may take you a while to recognize what subjects stir your emotions, but persevere because passion is a vital ingredient.

Take note of the changing seasons and try to capture the colours when you see them, either in the form of colour notes on your pencil sketch, or watercolour or pastel sketches when you feel ready. Ideally, spend more time looking than drawing.

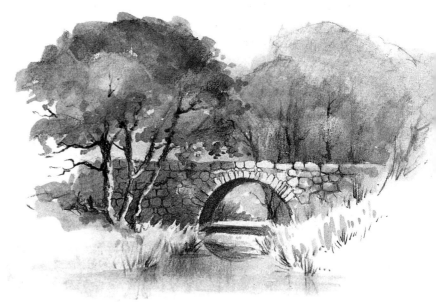

Working with just pencil and paper to begin with, start with the focal point. This could be a group of buildings, a tree with a gate, a bridge or a waterfall. Try not to make your focal point too big or there will not be enough room on your page for the landscape that surrounds it. Simplify what you see – it is fine to leave things out if they do not enhance your picture.

Notice which direction the light is coming from and see how it affects the elements within your drawing. Use shading to define the shapes and shadows and try not to get bogged down with too much detail. However,

▲ What initially caught my eye was the light on the bridge.

▼ Sometimes I let my imagination have full rein and, as far as I know, this scene does not exist.

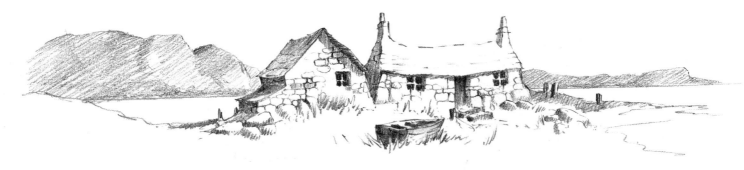

if there is a particular feature you really like, make a detailed sketch on the edge of your page or on a separate sheet.

Look out for people and animals that might be passing. Capture them quickly on the edge of your sketch as they will not wait around for you to be ready. You can incorporate them into your painting later on if they help your composition.

Cutting out confusion

If a scene seems confusing, try to look at it with your eyes almost closed so that all you can see are tonal values. This will help you to decide what the main shapes are and where to simplify the scene. You can also use a viewfinder, made from a rectangle of card with an aperture cut out, to look at your scene. Use it to isolate your subject and cut

▶ The waterfall in this photograph was surrounded by a mass of fallen trees. I isolated the more interesting elements using a viewfinder.

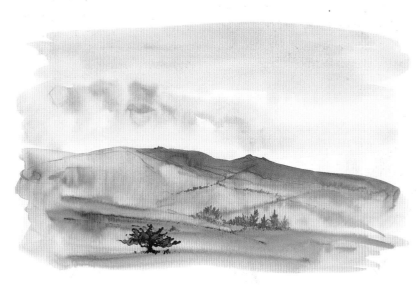

out all the unnecessary detail surrounding it. If the scene is crowded wth trees or buildings, look for the most shapely, interesting ones; emphasize them and exclude the rest.

When you are more confident with your pencil drawing, and feel ready to experiment, try adding some colour to your sketches. Add a few watercolour washes as it can be quicker than shading with a pencil. You could also buy a pad of tinted paper and use a few sticks of pastel, or some pastel pencils, to make some rapid pastel sketches.

◀ By using a sheet of tinted paper and a few pastels you can capture the weather in just a few minutes.

◀ A few watercolour washes can often be quicker to render than a pencil sketch to capture mood.

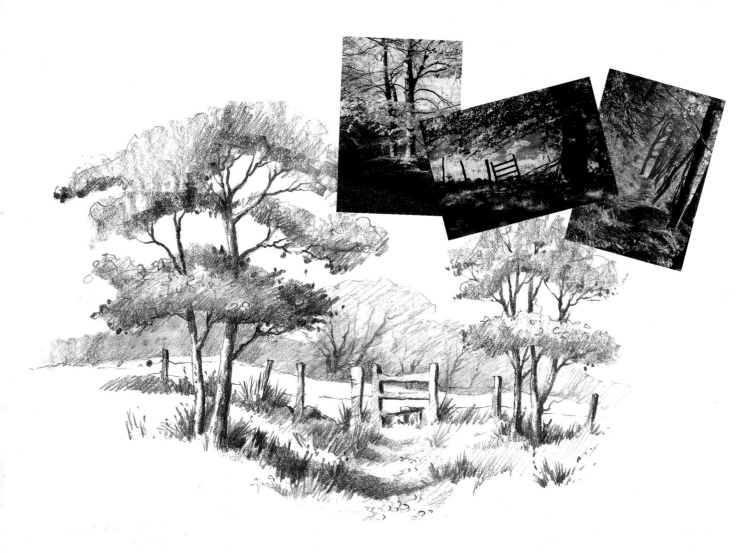

Painting on location

I rarely do complete pastel paintings out-of-doors because rain, wind and insects can all conspire to ruin my day. I prefer to sketch a scene, which can take as little as five minutes, and then work on the painting in the comfort of my studio. This way I can come home with several sketches to work from, instead of just one painting, and I have a rich source of ideas to use when I am no longer able to get out into the countryside.

However, paintings done on location often have a spontaneity that is missing from studio paintings. If you do want to work on painting out-of-doors, go well prepared with all your equipment organized and ready to use, otherwise you might miss that fleeting moment when the light is just right. Before launching into your painting though, it is helpful to do a quick preliminary sketch to sort out your composition.

It is a good idea to take some photographs as well as sketching a scene. Take shots of your scene from different angles as this information may be useful to complete your painting. The light will change as you are sketching, so take a photograph when you consider the light to be at its best. If you have a zoom lens, take some close-up shots as well as more general ones. Once you have returned to your studio, you can collate photographs and sketches to produce all the information you need.

Studio sketches

If you cannot go out, and have to work from photographs, it is helpful to start by making a studio sketch from your photographs. This process will help you to decide what should be included and what can be left out. You can move things around to suit your composition and, when you are ready to paint, the scene

▲ When you are ready to paint, collate all your information and plan your approach.

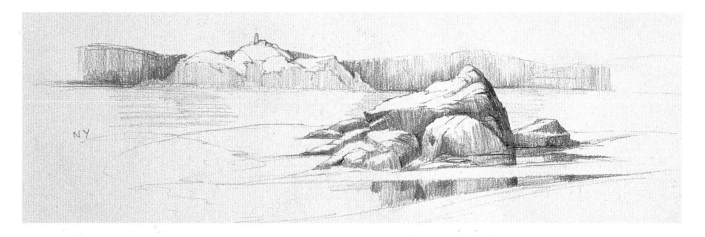

will be clearer in your mind. It is useful to remember that photographs tend to reduce the range of tones and colours that you can see in reality. They can also 'flatten' a scene, so try to interpret the photograph rather than copy it.

Develop your drawing skills

Practising your drawing skills will be time well spent. Just as musicians need to practise to improve their dexterity, so do artists. By working with only paper and pencil, just doodling and drawing, you will quickly develop control and sophistication in the marks you make. Try to use precise vertical strokes when shading and you will be surprised at how much more professional your drawings look.

Sketchbook journals

Keeping a sketchbook journal of your travels can be very rewarding, not only creating a resource for future paintings but a valuable souvenir of your trip. On overseas trips I make a habit of recording my thoughts and impressions alongside my sketches because this helps me to recall the circumstances and emotions that accompanied an event. If, and when, I decide to develop a particular sketch into a painting, these notes will help me.

▲ Improve your drawing skills by using deliberate shading to highlight shapes.

▼ This is a page from the journal I made while travelling through Tanzania.

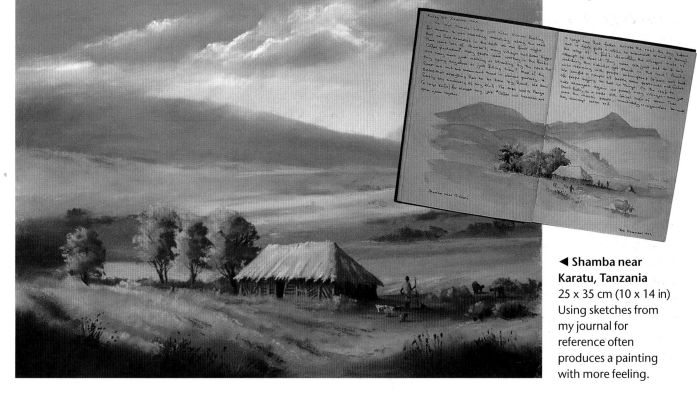

◄ **Shamba near Karatu, Tanzania**
25 x 35 cm (10 x 14 in)
Using sketches from my journal for reference often produces a painting with more feeling.

Composition

Although there are many rules about composition, it is only necessary to understand the basic ones to produce a pleasing result.

The first rule is to have only one focal point. Your viewers need to have a place for their eyes to rest in a painting. If there is more than one centre of interest, they may feel confused and dissatisfied because they will not be able to identify your main statement.

To emphasize the focal point you should try to reserve your strongest contrasts for this area alone, whether it is the lightest and darkest tones, the brightest and most vibrant colours, or both. Cast everything else in a supporting role.

▼ **Summer Meadow**
18 x 16 cm (7 x 6 in)
A high horizon can give impact to a painting as well as allowing an abstract approach to be used on the foreground.

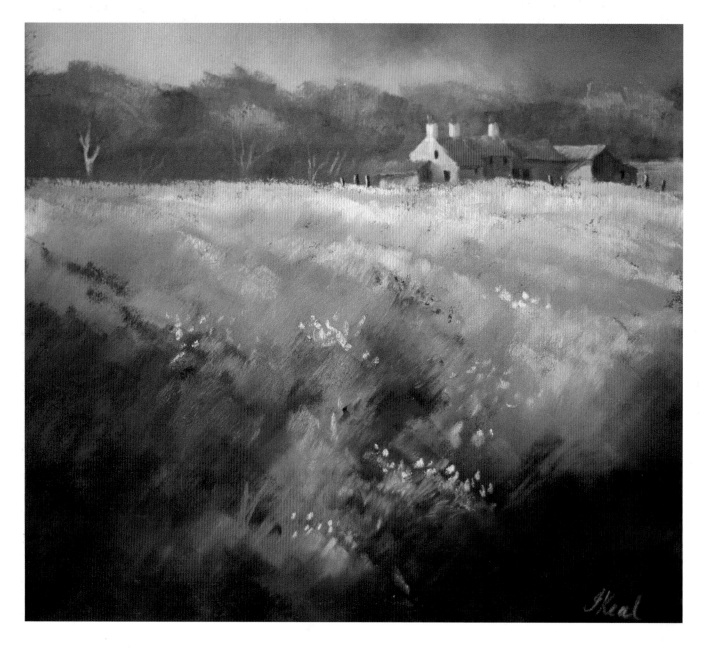

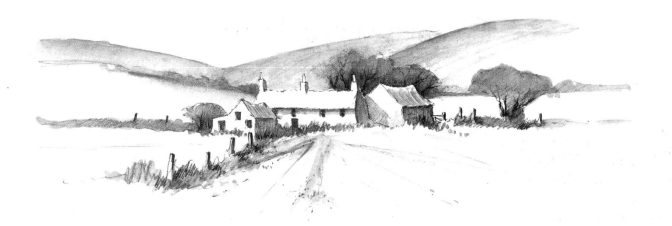

Position your focal point

Some people refer to an area called the 'Golden Section'. It sounds like jargon, but all it means is that it is better not to have your focal point on the edge or in the middle of a painting. Perceived wisdom says that if you draw a line one third of the way in from all sides of the picture, the box you have drawn is the golden section. Your focal point should sit somewhere just within, or on, this line.

It is not necessary to follow this strictly if it inhibits you, but consider the position of your focal point carefully. For example, if you want to paint an interesting foreground, then place your focal point in the upper third of your picture. Alternatively, if you would like to emphasize the sky, place your focal point in the lower third. Try not to divide the painting into two halves by putting the horizon line half way down the picture.

A meandering footpath, a stream or just the arrangement of the foreground foliage can all be used to lead your eye to the focal point. You can also use dry-stone walls, hedgerows or groups of trees to bring the eye to rest on your centre of interest.

A fence or wall positioned right across the foreground will create a barrier and inhibit you from getting to the focal point, so you can either create a gap in the wall or change its direction so that it leads towards your centre of interest. You can even use the contours of hills beyond your subject, by making them converge around your centre of interest, to concentrate attention on the focal point.

▲ In this sketch I used the fence and the ruts in the field to lead the eye to the focal point.

▼ Llanelwedd
17 x 35 cm (7 x 14 in)
Converging lines and subdued detail are employed to create recession in this snow scene. There is little tonal or colour variation.

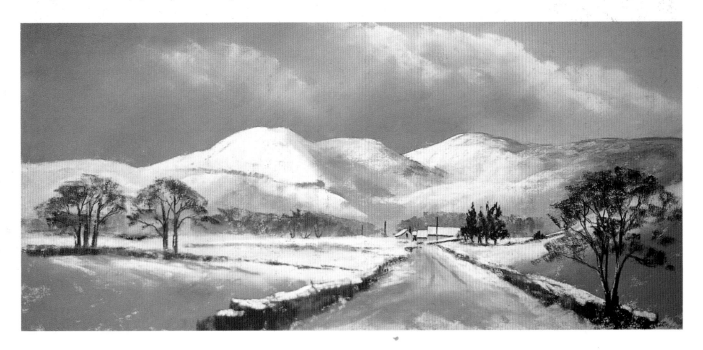

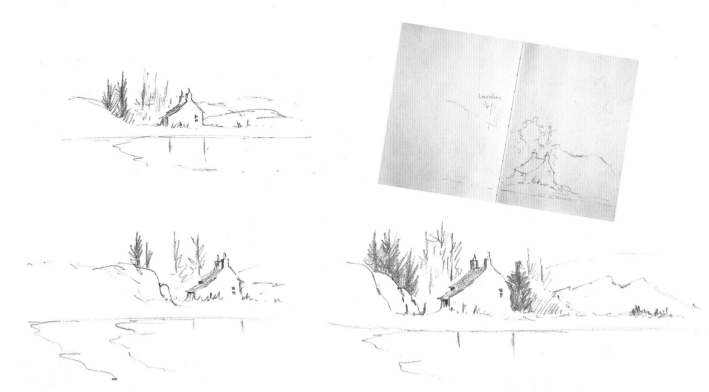

Doodle

When working out your composition it can be helpful to make several thumbnail sketches on a scrap of paper to plan the overall position of the elements in a painting. This will help you to decide where you should place the focal point and how it should relate to the supporting features. The shapes created by the light and dark areas will be the first impression your viewer receives, so try to use an interesting design.

A basic design will also help to keep things simple and will give a sense of harmony. Individual shapes are less important than the combined shape they create, for example, a subject that has a reflection. It is easier to see these overall design shapes, created by tonal zones, through half-closed eyes. If the pattern of light and dark areas is haphazard, your viewer will find your painting disturbing. Doodling on scraps of paper will also improve your drawing dexterity.

▲ A selection of composition doodles of **Cottage by Loch Reraig**. The original sketch for this painting was done in a torrential downpour, sheltering under some trees so that there was no time to do a considered study. However, the memory of the moment inspired my interpretation.

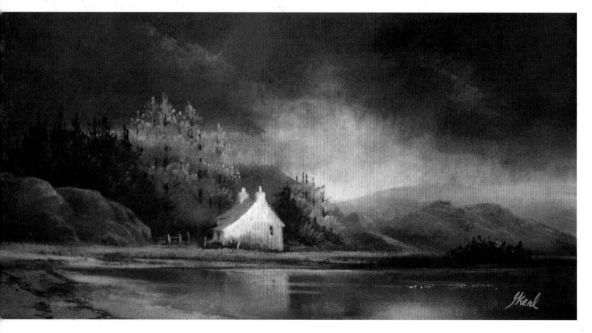

◄ **Cottage by Loch Reraig**
20 x 30 cm (8 x 12 in)
Capturing the mood of the moment was my priority here, so strong contasts and a limited palette were employed.

a

b

◀ The gap between the trees is as important as the trees themselves. The negative shape created in **b** is much less dominating than the one in **a**.

Negative shapes

Consider the negative shapes you are creating between the main elements. When your painting is finished these negative shapes can be quite dominating. An example of a negative shape is the gap between two trees. You may not have noticed what shape you were creating when you painted in the trees but, when you step back and view the painting from a distance, it can be quite distracting. Drawing the negative shape between two elements, instead of the object itself, is valuable drawing practice.

Which format?

You may find that your composition fits better into a portrait, that is, a vertical format. Tall trees, long waterfalls and street scenes often work better this way up. Also consider using this format to create a dramatic effect, such as a ruined castle keep on a hill or an arched bridge over a gorge. This format can also help to eliminate a lot of unnecessary detail either side of your focal point.

▶ Some subjects work better in a portrait format, such as this watercolour sketch of the bridge at the Hermitage, Dunkeld.

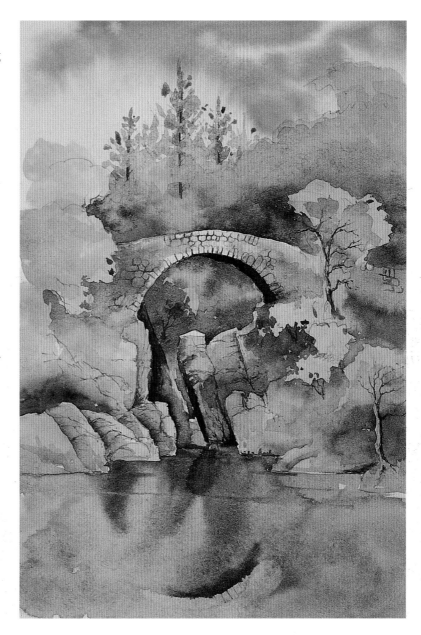

25

Creating recession

An important ingredient in a good landscape painting is a sense of distance. When you paint a landscape, you are trying to trick the viewer into believing that what they are looking at is three-dimensional and not a flat surface. There are several devices you can use to create this illusion.

Aerial perspective

The first of these devices is aerial, or atmospheric perspective. Colour temperature is an important element in creating recession. Distant hills are often blue grey or purple grey because moisture in the air diffuses and subdues colour to make them appear cool. Blue and purple are cool colours and so recede into the distance.

Features near to you, like the grass at your feet, can be painted with warm colours, such as warm green, yellow, or even red, to make them appear closer. Even if you see the distant hills as warm green, resist painting them that colour and use cool colours to create the illusion of recession.

Tone

Tone is also valuable for creating recession. Objects seen at a distance are often lighter in tone than those close to you. Observe this when you are sketching, as it is often more apparent in a real scene than in a photograph. Reserve the strongest tone for the area around your focal point and the foreground.

▲ Colour temperature is employed to create the illusion of recession.

◀ In this monotone, recession is created simply using tone.

Detail

The third device for creating recession is detail. You cannot, try as you might, see an object in detail if it is at a distance, but features close to you are normally clear and crisp. Soften the edges of distant features by slightly blending the pastel.

Use cool colours, lighter tones and soft edges to help distant features recede. Overlap some elements in your landscape and make objects close to you larger than those further away. Use strong colour and tone, and sharp detail, in the foreground and around your focal point to achieve the effect of recession. Also try using the weather to achieve this effect. Add a rainsquall to obscure part of a hillside or introduce mist to a valley. Smoke drifting from a chimney can make distant features appear indistinct.

Linear perspective

You can also use linear perspective to create the illusion of depth and space. However, it is generally only relevant in a landscape that includes buildings, so I have dealt with this subject on page 42. A basic understanding of linear perspective will enable you to make your buildings sit logically and appear solid within the landscape.

Step back

To check that your painting has a satisfying composition and a sense of recession, step back to view it from a distance of about 1.8 m (6 ft). This will identify any problem areas, glaring mistakes or negative shapes that are not developing in a satisfactory way.

▲ Here, a sense of recession is emphasized with detail.

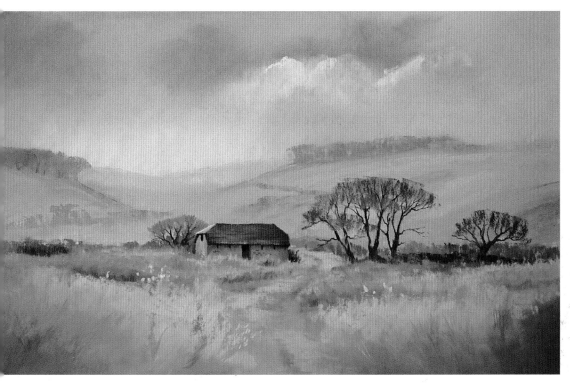

◄ **Sussex Barn**
15 x 25 cm (6 x 10 in)
Avoid problems with linear perspective on buildings by choosing a viewpoint where it is less apparent. Face on, perspective on this barn is much simpler to deal with.

Simplification

When you look at the landscape you will see that even the simplest scene has a lot of extraneous detail, which will do nothing to enhance your painting. Leaving out these unnecessary details will not only improve your composition, but will give you the opportunity to impose something of yourself, and your feelings for the landscape, onto your painting. A faithful reproduction of every detail is no different to a photograph; a painting should have an element of interpretation, which makes it as individual as you are.

Substitutes

If, however, you leave a feature out, for example a large modern barn, something will have to fill the space it leaves. Trees, bushes or a simple hedgerow are obvious substitutes. In a farm scene you could replace an ugly white caravan with an old tractor, adding character and narrative to the scene. For this reason it is useful to have a number of studies in your sketchbook, such as interesting farm implements, or bushes and trees, which could be used in this way. So when you are outdoors and see an interesting bush, tree or vechicle make a quick study of it to add to your stock of substitute objects.

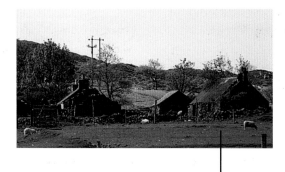

◄ This scene is cluttered with too many buildings.

◄ For this sketch I picked out the building I really liked.

◄ **Cottars Croft**
15 x 26 cm (6 x 10 in)
I concentrated my attention on what excited me most and left out the clutter.

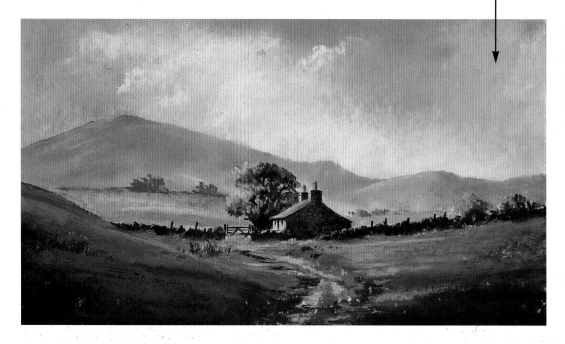

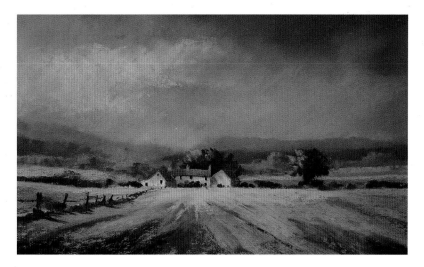

◀ **Stubble Field**
18 x 25 cm (7 x 10 in)
A loose treatment of
the foreground field is
often more successful
than a lot of laborious
detail. It is fine to omit
buildings, cars and
ugly caravans.

Essential elements

A hillside cloaked in trees can be simplified by using sweeps of colour instead of trying to depict every tree. Likewise, a distant heather-clad moor, or even a mountainside, can be portrayed with subtle variations of colour.

There is no need to draw in every leaf or blade of grass, just a sweep of colour will hint at foliage and the viewer will do the rest. Leaving some areas with little detail will enhance the centre of interest, concentrating the eye where you want it to rest.

Reducing a scene down to its essential elements is also a good exercise. Perhaps putting in less than you think you need in order to see how little is necessary to make a painting successful. When looking at a scene, try squinting so that all you see are some simple shapes. This is a good way to filter out all the detail, leaving just the main areas of light and shade.

Soften and blend

Hard edges can give the impression that there is a lot of detail in a painting. To concentrate the attention on the focal point, and reduce the detail, soften and blend edges so that there is a more subtle variation in colour in tone. Remember to keep the hard-edged detail mainly concentrated around the focal point.

▼ **Milford Haven**
22 x 33 cm (8½ x 13 in)
Don't forget that
industrial scenes make
good subjects too.
Using the weather to
obscure a lot of detail is
more likely to result in a
successful painting.

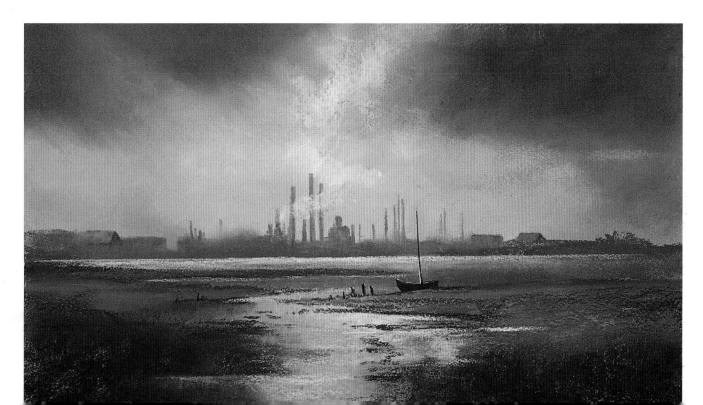

Creating Detail

In the last section I discussed simplification and the importance of keeping detail to a minimum to give your paintings vitality. However, if you want your focal point to stand out strongly, it is sometimes necessary to portray some fine detail in this area.

Pastel is not a medium that is automatically associated with fine detail. It is not easy to get a clean sharp edge or to create fine lines with a pastel stick. However, using a combination of broad strokes with a stick of pastel and a well-sharpened pastel, or charcoal pencil, it is possible to create intricate architectural details and fine branches on trees and bushes. Keeping the colours clean, using sharp-edged detail and strongly contrasting tones, will emphasize your focal point, especially if you subdue the detail and tones in other parts of the painting.

Because pastel is essentially a drawing medium, and it is applied by direct contact, a great deal of control can be used. You can also work up a painting to a fine degree of detail by using colour shapers to manipulate the pastel once it has been applied.

Clean lines

If you find that your pastel stick is too clumsy to obtain a straight edge, you can draw in the line with a pastel pencil and then backfill the

◀ A few dabs of colour are just enough to suggest the presence of these foxgloves.

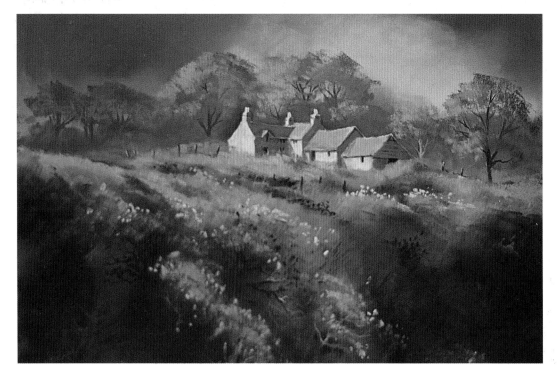

◀ **Farm near Rhayader**
24 x 25 cm (9½ x 10 in)
I used pastel pencils and colour shapers to achieve a fine degree of detail on the farmhouse.

space with a stick of pastel. If you inadvertently go over your newly created edge, you can either restate the background to tidy up the smudge – I call this 'cutting back'– or clean up the edge using a chisel-ended colour shaper. Sometimes it is possible to draw in an entire building using pastel pencils and, of course, this will give you a high degree of control.

Pastel pencils usually work better on abrasive paper because the rough surface draws the colour out of the pencil better than the average pastel paper. By using abrasive surfaces I can work the pencils over an area already covered in soft pastel and still obtain strong colour and tone. If you try this on pastel paper, the pencil skates off and will not 'take'.

A sharp charcoal pencil is ideal for drawing the fine filigree of branches on a winter tree, or the stray branches that enhance the appearance of summer trees. Drag the pencil sideways, twirling and twisting it to get a natural appearance on contorted branches, lifting the pressure so that the branch gets thinner towards the end of the stroke.

◀ Old stone walls are full of colour.

Use a charcoal or pastel pencil for building features, such as chimneys, glazing bars of windows and detail on doors, joints in dry-stone walls and brickwork, which all need a degree of detail to make them believable.

Use a white pastel pencil to draw in light masts on boats or the horizon line on distant flat water. Sparkle on water, or detail on a waterfall, can all be achieved using a white pastel pencil. All you need is a white and black, a few grey pastel pencils, together with one or two brighter colours for figure work. A complete set of pastel pencils would be an extravagance.

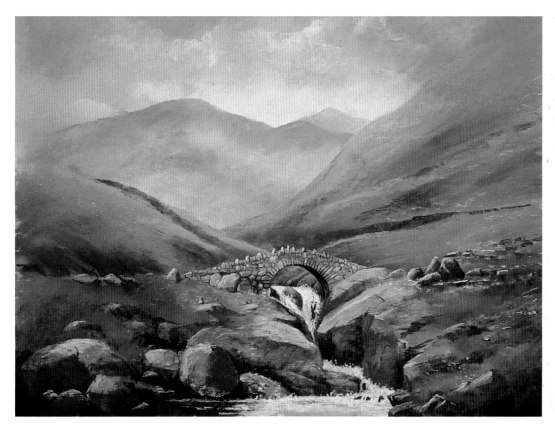

◀ **Stockley Bridge**
25 x 33 cm (10 x 13 in)
I used a well-sharpened charcoal pencil to draw in the stones on the bridge.

Skies

Before commencing your landscape painting it is important to consider the treatment of the sky. It will set the mood for your painting and determine the direction of the light. This is a vital component in the decision-making process for your composition.

A bright blue cloudless sky can be useful if there is a lot of interest in the rest of the composition, making the role of the sky less important. However, introduce white fluffy clouds and you will be indicating the direction of the light.

On a clear day, try to observe the way the sky lightens towards the horizon and sometimes becomes a shade warmer. This effect will heighten the sense of recession in your pastel paintings. Try using warm colours in the area of sky where the light is coming from and cooler colours away from the strong light.

A strong, dramatic sky will dominate your painting and can be used effectively with a simple composition. Indeed, it is better not to have too much competing detail in a landscape with a powerful skyscape. A low horizon line is helpful if you want to keep the attention on the sky and the detail in the foreground to a minimum.

Simple skies

Successful simple, cloudy skies can be quickly created using just a series of purple greys and blue greys, with a hint of white for the lightest areas. A touch of pink or Naples Yellow can be introduced to add extra interest. Use the shapes within the sky to complement your composition. Paintings with a high horizon line will benefit from a simple sky. A useful way of indicating the direction of the light is to make the sky

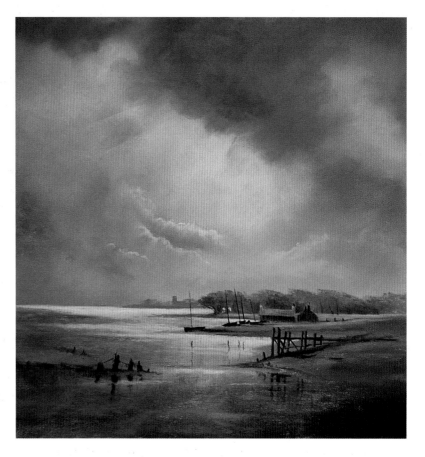

▲ **Thornham**
25 x 25 cm (10 x 10 in)
A low horizon gives more emphasis to a dramatic sky.

◀ A simple, clear blue sky – slightly lighter at the horizon.

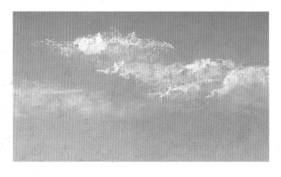

◀ Adding a few clouds indicates the direction of the light.

32

lighter on one side graduating to dark on the other side. This can be helpful if you would like to introduce counterchange into your painting.

Cumulus clouds

Cumulus clouds can be so interesting that they make a subject in themselves. If you want to turn your cloud studies into paintings, just an indication of fields and trees, or fairly featureless marshland will be enough.

Wind-torn clouds will give a sense of movement, which should also be evident in the rest of the painting. For example, by indicating wind in the trees or ripples on the water. To create these ragged clouds use diagonal strokes, leave rough edges and make sweeping strokes with your finger to blend where necessary.

Storm and tempest

A lively storm-torn sea is a delight to paint, so use the sky to set the mood by adding racing clouds, ragged edges and strong tonal relationships. Even in a dark grey sky, introduce some warm colours to give excitement. Use the dark of the sky to great effect by contrasting with some crashing white waves.

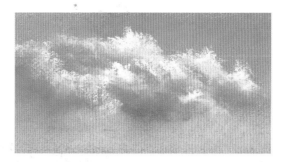

◀ It is possible to emphasize strong directional light by using stronger shadows.

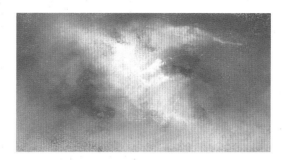

◀ A window in the clouds can be used to complement the composition.

Sunsets

A vibrant sunset is the most tempting type of sky to paint for an artist. However, a certain amount of restraint is necessary as vibrant reds and yellows tend to look 'over the top' in a painting. Beware of painting the landscape or seascape associated with this type of sunset in complete silhouette just because it often appears like it in reality and in photographs. Try to introduce a certain amount of detail into the landscape, but keep it to a minimum and use subdued tones.

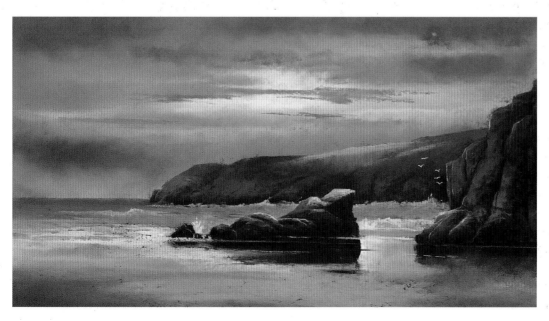

◀ **Presipe Bay**
18 x 34 cm (7 x 13 in)
A colourful sunset is more effective if the colour in the landscape is subdued.

Trees

It is difficult to imagine a landscape painting without trees, unless, of course, you live in the arctic or the desert. In Britain, trees are a vital part of the landscape and if you visit any of the more windswept areas, you will immediately notice either a lack of trees or, if there are any, how stunted they look.

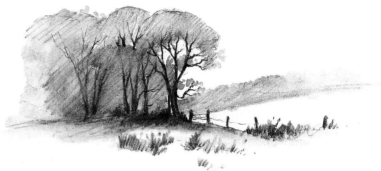

▲ When drawing a group of trees, make the end one interesting and subdue the rest.

Groups of trees

The vertical nature of trees is useful if your painting tends towards the horizontal, so use a strategically placed tree, or group of trees, to add interest where it is needed. Groups of trees can also be substituted for something you wish to leave out of a composition.

Beware of painting your trees an equal distance apart as they can look artificial, like a row of soldiers. Painting two or three trees together and one alone is more effective. In a group of trees the end one is the most important, so make it shapely and interesting. The rest can then be hinted at rather than describing individual trees in great detail. Overlap the tree shapes to create a more realistic rendition.

In a woodland scene all you will see of distant trees will be their trunks, the distant foliage being obscured by closer trees. Use tonal values and colour temperature to give a sense of distance. Place some trees and branches in front of others to give a realistic look to the wood. Don't forget that foliage casts strong shadows so use these strong tones to emphasize your focal point.

Massed trees

Being confronted with a hillside covered in trees can be daunting, however, simplification is the answer. Indicate the outline of the trees on the horizon and then hint at the rest with broad sweeps of colour. Vary the tones then blend and soften the edges. Try not to get bogged down with detail as that will bring the hillside closer.

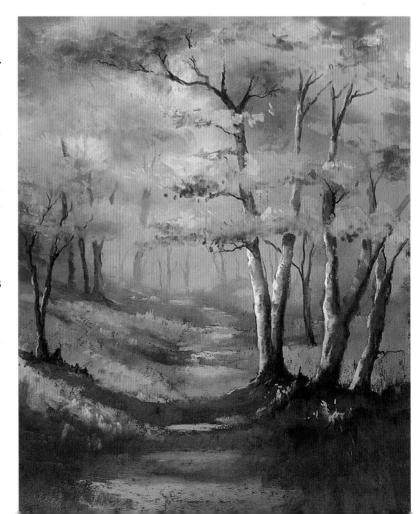

► **Woodland Walk in Spring**
25 x 19 cm (10 x 7½ in)
To create recession in a woodland scene, try to subdue the detail in the distant trunks, make them smaller, cooler in colour and lighter in tone.

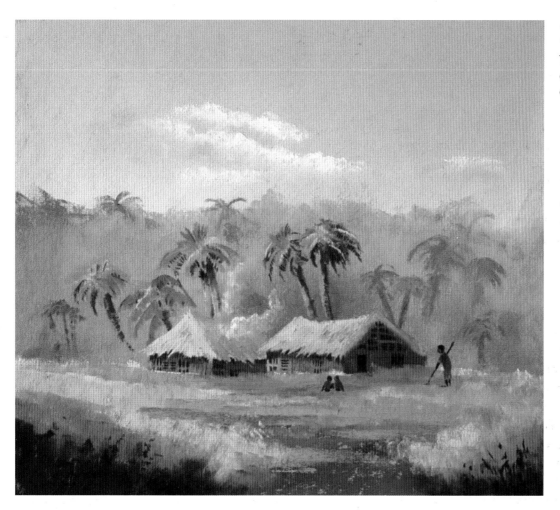

◀ **Zanzibar**
19 x 20 cm (7½ x 8 in)
Trees in a landscape
can denote an
exotic location.

▲ Detailed studies of
unusual trees are a
valuable resource.

Overseas

Trees can help to establish a sense of place in a painting and are a good indicator of the continent you are visiting. Put in a palm tree and your viewer will immediately think of warmer climes. Therefore, it is important to capture the different types of tree when you are sketching abroad.

Focal point or supporting role?

You can use trees as your focal point or they can be employed in a supporting role, for example, to emphasize the roof and chimneys of a building. Trees are often planted around remote farms in windswept places to give shelter and, where they do not obscure the farm, they usually provide an agreeable frame to the buildings.

When you are out sketching trees, single out the trees with the most character. Look for the ones with an elegant shape, with lovely contorted branches or a gnarled and twisted trunk, or those covered in moss and ivy. There is little point in sketching boring trees.

Carefully examine the colour of the branches and trunks because they are rarely as brown as you might imagine, more frequently they are green with algae and lichens. Notice how the foliage casts shadows across the branches, especially just underneath. Look for branches that grow towards you as well as sideways and upwards. These details will give your trees a more three-dimensional effect.

Notice how the lower part of the trunk will often be light against a dark background, but as you go further up the branches appear dark against a light sky. This effect is called counterchange.

Changing seasons

In Spring, the clean, fresh greens are bright with promise and give you an opportunity to use a few of your brighter pastels. At this time of year you are often still able to see the underlying structure of trees, with a light smoky cloak of vibrant green hinting at the bursting buds.

In Summer, grappling with greens can be a problem in a painting. A cursory glance at the summer landscape will often give an overwhelming impression of green but, if you take the time to look carefully, you will notice that there are many other colours in your scene, especially in the shadow areas.

Use these colours to make your summer landscapes less monotonous and to give your paintings more variety. Use a yellow to indicate the light side of a tree, a warm green for the middle tones, and where the foliage is in deep shadow use a dark purple or mauve. Also use these colours for the cast shadows under a tree to unify the dark areas. A hint of red is often apparent in summer foliage and, by adding these other colours, you will relieve the predominance of green.

Try not to use too many different shades of green in your summer paintings. Aim to stick to cool Green Greys for distant trees and Olive or Sap Green for the foreground trees. Leave the vivid emeralds and grass greens in the shop.

▼ Spring trees (a) are bright green. Summer greens (b) are much warmer. Autumn tints (c) need subtle handling and winter branches (d) are often Red Grey.

a

b

c

d

▶ **Out to Pasture**
15 x 29 cm (6 x 11½ in)
Summer trees can be overwhelmingly green, so use bright yellows for the sunlit areas and perhaps dark purple grey for some of the shadow areas, just to give some relief from the green. Notice the colours used in the foreground grass in the shade.

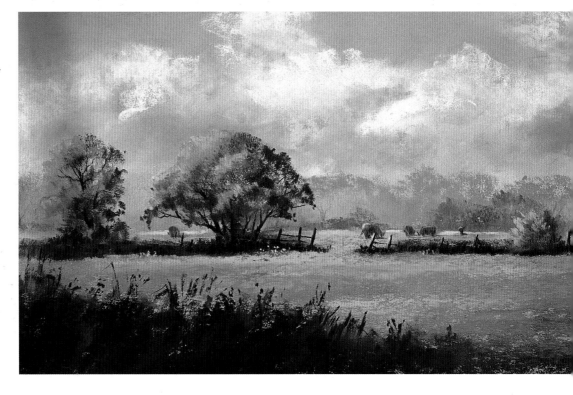

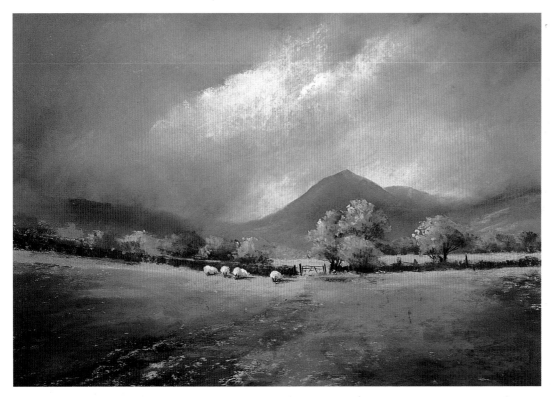

◄ **Autumn in the Hills**
25 x 36 cm (10 x 14½ in)
In this painting complementary colours are used to add drama and to give the bright colours on the trees a warm glow.

Autumn is probably the best time of year to paint trees as it is a wonderful opportunity to use the strong, vibrant reds and yellows that you could not resist buying in the art shop. Try to use complementary colours in an autumn landscape, for example, use a purple blue hill to juxtapose with a bright yellow birch tree.

Winter trees are a delight to paint. Now is the time to study the structure of the tree so that you are able to create a more realistic interpretation of trees in other seasons. A fine filigree of branches against a winter sky can be evocative. Use a Red Grey pastel stroked on its side to hint at the filigree of twigs that give a tree its outline.

▶ **Winter Feeding**
22 x 25 cm (8½ x 10 in)
The filigree of bare winter trees against a snow-laden sky is achieved using a sharp charcoal pencil.

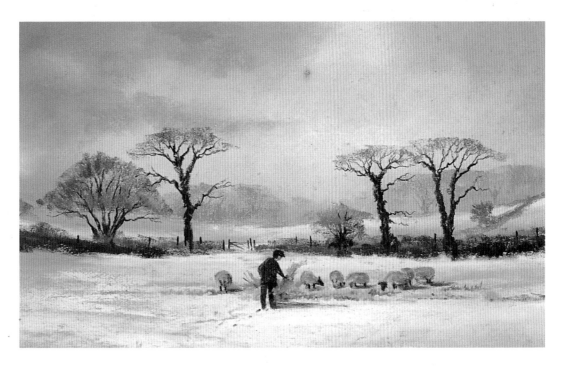

Water

It is impossible to ignore a glimpse of a reflection in still water, the sparkle of light on a rippled lake, surging energy in a wind-torn sea or the splash and tumble of a mountain stream. This life-giving element is not only a vital part of our existence but adds movement and mystery to our painting.

Reflections

We have all seen, whether in a photograph or in real life, a perfect reflection, a mirror image in a still surface. For the purpose of a painting, however, the mirror image is best avoided. The inverted double image can be confusing to the eye, so a slightly diffused reflection tends to be more attractive and pastel lends itself readily to this effect.

Start by painting the features to be reflected then, in the adjacent water, paint in exactly the same colours, ensuring that there are some strong tonal contrasts. Now blend the colours in the water, first by pulling the colours directly towards you and then hint at some horizontal movement. With a little practise you can achieve subtle and pleasing reflections.

When planning your painting, remember that reflections should be part of your overall design. Consider in advance the shapes you will be creating with the strongly contrasting tones necessary to make the reflection work. Plan your composition so that you have a light area next to a dark area in the features to be reflected, since this is the most critical area of your reflection. Step back and look at your work from a distance to consider whether you are creating a good design shape.

Sparkling water

A rippled surface on water will catch the light and bounce it back. Use this phenomenon to lift a dull scene. Moonlit lakes and rivers are a good example of simple but effective scenes using this technique.

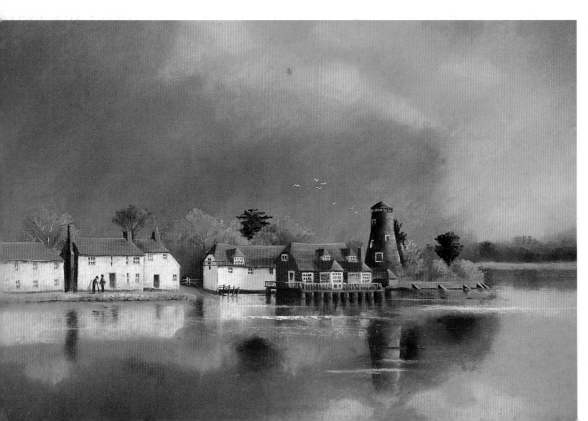

◀ **Langstone**
61 x 71 cm (24 x 28 in)
Break up strong reflections with a few ripples to give a sense of movement in the water.

Moving water

The crashing, tumbling, foaming, splashing water of a mountain stream or waterfall is a challenge to capture but, because pastel allows you to lay light tones over dark ones, you have a real advantage.

To accentuate the whiteness of water, you need to make the rock surrounding it dark. If you study a waterfall, you will notice that this happens naturally because the growth of moss and algae in the splash zone generally darkens the rocks near the water anyway. If you paint a splash of white water in the wrong place, remove it by blending it in or restating the dark area.

Falling water is not completely white and there are some areas of light and shadow, so use these to indicate the movement of the water. Use directional strokes of white pastel and stray dots to hint at splashes. Try to suggest the power of the water as it surges quickly through the narrowing rocks. At the edge of a waterfall there is often a stray trickle of water that has escaped the main flow.

Streams cascading over rocks often present a complicated composition, so focus in on one particularly attractive area with a pleasing interaction of rocks and water. Identify your

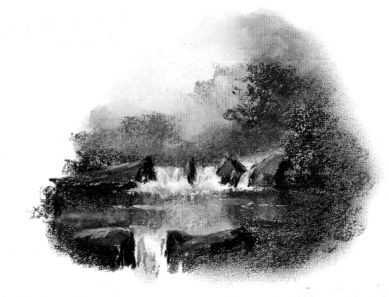

focal point and use the strongest tones and the sharpest detail in this area, subduing the supporting features.

▲ Juxtapose white pastel against dark tones to describe falling water.

The sea

Surging waves, crashing surf and the ceaseless movement of the water convey the terrifying power of the sea. If you can be by the sea when it is in this mood, let yourself be mesmerised. Study the wave patterns before sketching, take in the detail of the patterns of foam, the spray and the energy. Use sweeping strokes to describe the water.

▶ **Incoming Tide**
20 x 30 cm (8 x 12 in)
Soft and hard edges are used to capture a sense of the constant movement of the sea and the surging waves crashing against the cliffs.

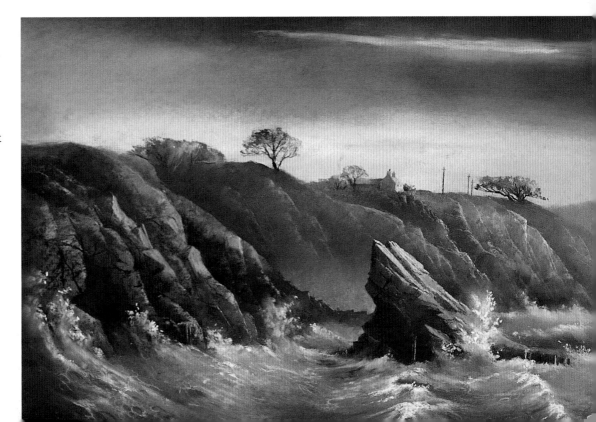

Buildings

Old buildings are favoured subjects in landscape painting. They provide an ideal focal point and evoke feelings of man's association with the countryside. Vernacular architecture is a particular passion of mine, and I am always happiest when tramping the uplands in search of a deserted farm or, even better, an unspoilt croft house with smoke curling from the chimney. Nostalgia is my only excuse, but these old dwellings do make charming subjects, and a certain amount of dilapidation adds to the charm.

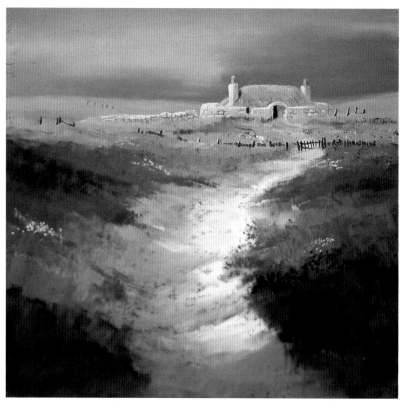

a Pembrokeshire Cottage

b Yorkshire Field Barn

c Lincolnshire Farm

A sense of place

In the past, building design varied according to the materials available, so it is important to notice and record the overall shapes, proportions and styles of old buildings, as well as the little details. Making a study of the common features in local vernacular architecture is a rewarding pursuit and will give a 'sense of place' to your paintings.

▲ **Tigh Geal, Tiree**
25 x 20 cm (10 x 8 in)
The way that building styles vary from place to place is a great source of fascination for me. This traditional home, found on a windswept island off Scotland's western coast, is designed to withstand Atlantic gales.

◀ Pale slurry-covered roofs (**a**) are a feature of Pembrokeshire cottages. Yorkshire field barns (**b**) often follow the contours of the landscape. Linconshire farms (**c**) are mainly red brick under clay roof tiles.

Don't make buildings too big; leave room for the landscape.

a

b

c

In Britain, local stone dictates the character of the buildings you encounter. For example, lovely old red sandstone in Devon and Somerset, warm yellow sandstone in the Cotswolds and the austere grey colours of limestone and grit-stone in the North. Where stone is in short supply timber framed structures are prevalent, as seen in Hereford and Worcester and the South Downs. In the windy, west of Wales an ingenious method of covering roofs with cement slurry gives the old cottages and farmhouses a distinctive and unique appearance. This rich variety of building styles is an endless resource for landscape artists.

Overseas travel can open up a whole new area of study. For example, red pantile roofs and warm-coloured stone walls in southern European countries make delightful subjects and present an opportunity for you to use colours from the warmer end of the colour spectrum. Further afield, dwellings constructed with less substantial materials, such as bamboo, banana leaves, and mud and straw, will give an exotic flavour to your paintings.

▲ If you can, make chimneys **(a)** appear to be part of a wall. Note the subtle shadows cast by window recesses **(b)** and study stonework around old doorways **(c)** for authentic details.

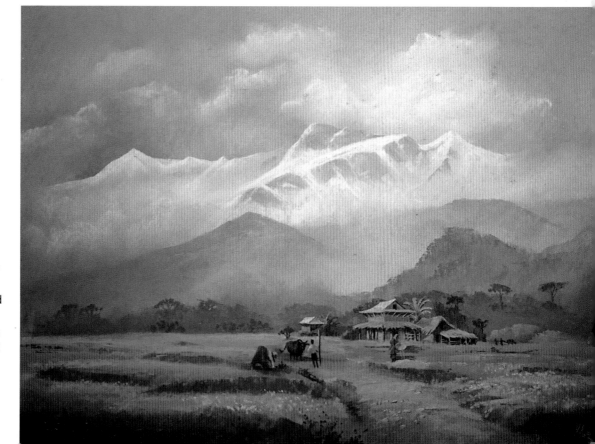

► **Farm in the Annapurna Foothills**
36 x 46 cm (14½ x 18 in)
In this painting it is the farm, built with giant bamboo, and mud and straw, which indicates an exotic location. The mountain alone would not give you this clue.

Authenticity

To give your buildings an authentic look, notice how, the older they are, the more they seem to grow from the ground, becoming part of the landscape. Sagging roofs and rounded corners add to this impression and the lower parts of the walls are often green with moss. Rather than drawing a straight line where the structure meets the ground, let the undergrowth intrude into the wall area to break up the base line.

Painless perspective

Working out the correct perspective on buildings should only be a concern where the subject is quite close to the viewer. Buildings in the middle distance are not usually affected by severe perspective problems. If you place them in your paintings so that they appear to be farther away, these perspective lines are less acute and in some cases can be ignored altogether. Alternatively, you can position yourself so that you are face on to the building where you will see very negligible amounts of linear perspective and still produce a satisfying composition.

However, an understanding of linear perspective will be another tool in your toolbox. Just as objects become smaller the farther away they are from your eye, so the horizontal lines that describe the eaves and roofline of a building will diminish as we look along them.

What creates confusion when using linear perspective is that the direction of the diminishing line depends upon your viewpoint. If you are looking down on a building, the horizontal roof line will appear to rise towards a vanishing point on the horizon. If you are looking up at a building, this line will appear to move down towards the horizon. If the centre of the building is at your eye level, the roof line above you will go down and the baseline, which is below you, will rise to meet at the vanishing point.

Whilst you are getting to grips with these concepts, stick to sketching and painting buildings in the middle distance and avoid complicated street scenes and close-up views of buildings. Tackle these subjects later on when your confidence has increased.

Linear perspective: **(a)** with a building slightly above the eye level, the line of the roof and the eaves slope down towards the vanishing point on the horizon; **(b)** with a building below your eye level the roofline and eaves slope up towards the vanishing point on the horizon.

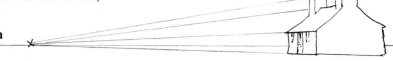

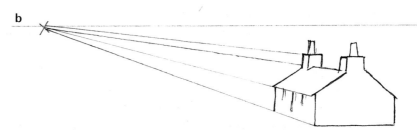

▼ Perspective is at its most obvious in street scenes but if you position yourself, in this case right in the middle of the road, the perspective is less severe.

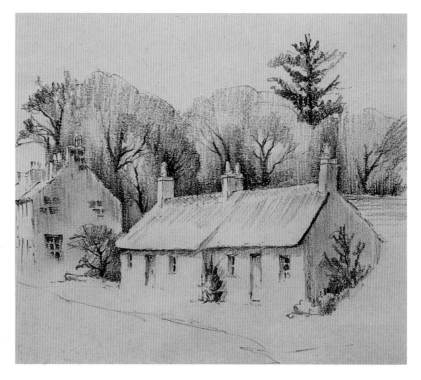

Light and shade

To give your buildings a three-dimensional appearance it is necessary to study the direction of the light and the areas of shadow, especially in the window and door recesses and the side facing away from the light. For example, notice how a shadow is cast over part of the glass and glazing bars. On a dull, overcast day observing this effect can be a problem. However, strong sunlight will soon reveal the secret and, once you have grasped the principle, it is possible to visualize the light and apply it to any building.

Supporting features

Most buildings benefit from supporting features, especially trees and foliage. Use trees to emphasize the outline, hedgerows to lead the eye to the focal point and bushes to disguise ugly or unnecessary details. Decide at the planning stage of your painting whether the roof and chimneys are going to be light against a dark background, or dark against a light background. This is probably the most important decision you will have to make regarding your composition as it will determine the treatment of your focal point and what supports it.

Consider using counterchange on a building; you can paint the roof light at one end against a backdrop of dark trees, and dark at the other end against a light field, graduating the tone as though a cloud had cast a shadow across one end of the building. Techniques like these will give a sense of authenticity to your work.

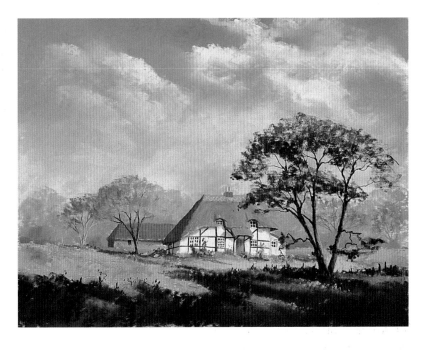

▲ **Horsebridge, Hampshire**
25 x 33 cm (10 x 13 in)
Emphasizing the shadow areas on a building help to give it a three-dimensional appearance.

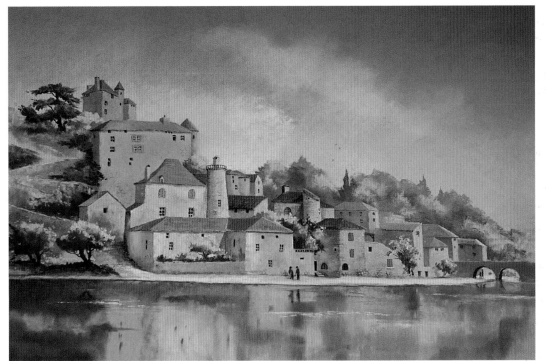

◀ **Puy L'Eveque, Lot**
36 x 53 cm (14½ x 21 in)
When confronted with a complicated scene like this, study how each building is related to its neighbours and the composition will fit together like a jigsaw puzzle. The buildings in the centre of the painting have more detail than those around the edges.

Animals and Figures

Figures and animals are very useful tools if you want to inject a sense of activity and life into your paintings.

Simple shapes

Keep the figures and animals in your landscapes quite small, since it is easy for them to dominate a painting if they are too big. Otherwise you end up with a portrait of a person or an animal, which is quite another genre of painting.

If you are going to include figures or animals in your landscape, consider where they are going to be at the planning stage. They should be around the focal point as the eye is always drawn to figures; you do not want them to compete with your focal point. The figure itself could be the focal point, so make sure it is placed correctly. A figure will work better if there is no detail behind it to confuse the image, so placement is vital. Is the figure going to be light against dark or dark against light? All these things need to be planned before you start to paint.

Animals

An empty farmyard will look deserted and abandoned, so populate it with some chickens. Groups of animals look better than individuals dotted all over a field. Try not to paint creatures looking towards the edge of your picture, as it will give the impression that something more interesting is happening outside the frame.

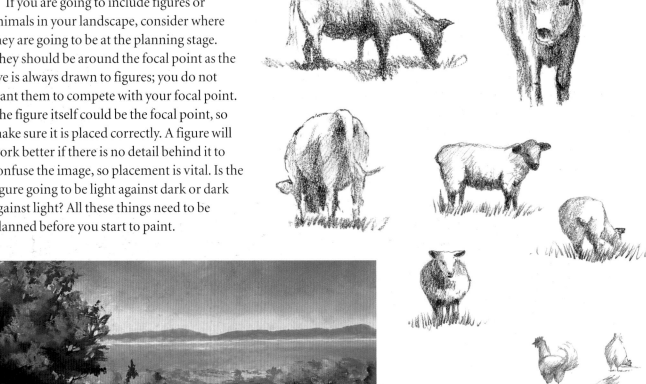

▼ Put life and character into your farm scenes with a few animals, such as cattle, sheep and chickens.

◄ **Keeping Cool**
24 x 33 cm (9½ x 13 in)
Sheep sleeping in the shade of the tree to give this scene the feeling of a hot summer day.

Figures

Figures in a landscape, or village scene, can also be part of a narrative style of painting. Sometimes you may wish to say a little more about a place, rather than simply stating that it is an attractive view. For example, the bent figure of an old farmer feeding his few remaining sheep could prompt the viewer to imagine his daily struggle, and even evoke a feeling of concern.

A distant figure can be portrayed with a simple egg shape for a head and just one or two strokes to indicate a body. There is no need to put in hands or feet. Hunched shoulders and a lowered head indicate old age; add a stick and a cap to create an old man. Make the figures do something if possible. Put two people together facing each other to indicate that they are having a conversation. Give them something to carry to show that they are on an errand.

On overseas trips, figures become even more important. What could give a sense of place more readily, in, say, a third world country, than the colourful and exotic garb of the local inhabitants? Observe carefully and make studies of headgear, what is being

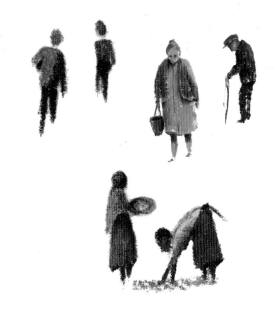

◄ Distant figures can be rendered with a few simple marks, using brighter colours for people overseas. To give your figures character, however, study their attitude and stance, their dress and what they are carrying.

carried and how. Notice things like attitude and bearing, and what tasks locals are doing, as this can often give a sense of place too.

When sketching overseas it is inevitable that you will attract a crowd of onlookers, usually children, who are curious about what you are doing. It is probably unusual for them to see someone sketching if it is not part of their culture. Try not to be intimidated by this attention, but enjoy the experience. Art is a universal language and can break down barriers quickly.

▼ **Maasai Herdsman on the Serengeti**
15 x 25 cm (6 x 10 in)
The bright red of the Maasai's blanket is a perfect focal point in the vast plain of the Serengeti.

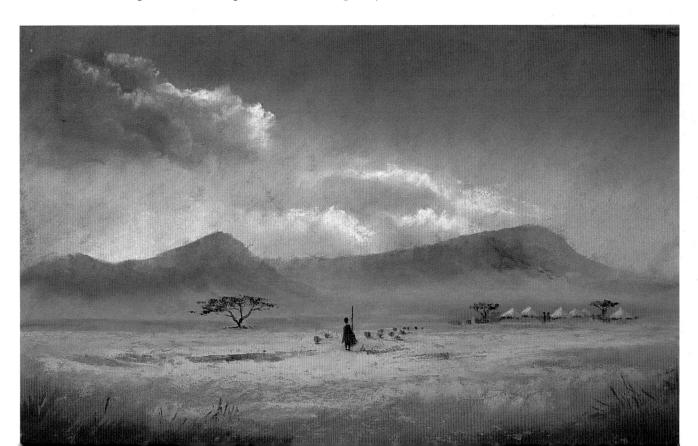

Sunlight and Shadows

Without light you would see nothing, so the quality of the light is the most important element in a painting. A shaft of sunlight behind a dark cloud, spotlighting an area of hillside, can be all that is necessary to make a painting. The excitement of seeing such effects can sometimes stop me in my tracks, as I commit to memory the visual impact of the light.

In Britain there are quite a few grey days with little directional light. It is often necessary to use your memory and imagination when sketching outdoors or working on paintings in your studio. Therefore, when the sun is shining brightly make full use of the moment and observe carefully what effect strong directional sunlight has on buildings, trees, hillsides, water, and so on. For future reference make sketches, not necessarily of the composition, but of the effects of directional light.

Local colour

This is the actual colour of an object. For example, a black roof on a croft house on the Isle of Skye. If, however, it is reflecting a light sky, it could appear as the lightest part of a painting and not appear black at all. Conversely, a white chimney in shadow could appear to be almost black if it is silhouetted against a light sky. So, for the purpose of a

▲ When the sun shines, notice how the time of day affects the light and shade on trees. Side lighting helps to give the trees form.

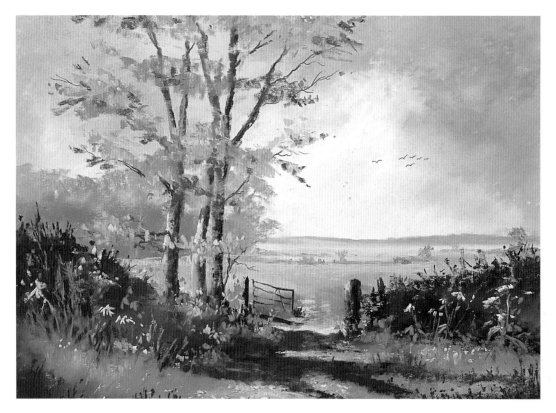

◄ **Beech Trees**
25 x 33 cm (10 x 13 in)
Introduce more unusual colours to give added interest to the shadows.

painting, it is sometimes necessary to ignore the actual colour of an object and observe carefully the effect of the light on it.

Colour of shadows

Notice the colour of shadows and see how much colour they possess – they are not always as blue as you might imagine. Local colour is often enriched by being in shadow, so an area of grass in shadow may be a deep shade of green, while a red sandstone wall could become a deep shade of burgundy.

Shadows and sunlight

It is the strength of shadows that accentuate sunlit areas. The darker they are, the brighter your sunlit area will appear. Bright light will also bleach out detail, so to depict a strongly lit area leave out detail, emphasizing it in the shadowed area adjacent to your sunlit area. Light and shade help to describe the three-dimensional nature of buildings. Study the shape and intensity of the cast shadows when the sun is shining.

▲ Highlights will be intensified if you make your shadowed areas very dark.

It is the quality of the light that dictates the intensity of the colours.

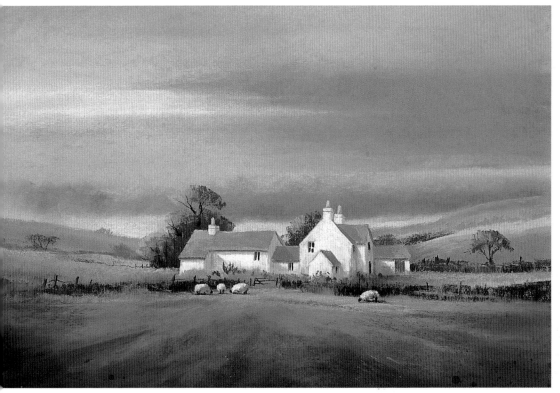

◄ **Afternoon Light**
25 x 33 cm (10 x 13 in)
Light and shade describe the three-dimensional nature of these buildings.

Mood and Atmosphere

It would be great, would it not, if the sun always shone? Well, not for an artist. A diet of unremitting, wall-to-wall sunshine could be a little too tame for the landscape painter. And where would you find the necessary mood and atmosphere?

It could be argued that it is the weather that has made the tradition of landscape painting in Britain so strong, and given such variety and interest to the work of landscape painters for centuries. The British countryside is a wonderful resource for landscape artists, with muted colours and interesting weather to provide challenging scenes to paint. The weather can also be used to your advantage. A rainsquall racing across a hillside can be used to break up a continuous line in a painting. Cloud shadows are useful to suppress detail in one area and accentuate it in another. Mist can be used to simplify an otherwise complicated scene, allowing you to make your focal point more prominent.

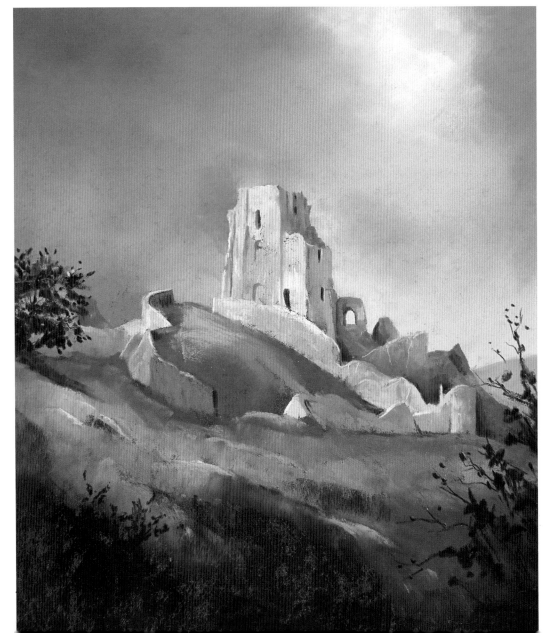

◀ **Corfe Castle**
25 x 20 cm (10 x 8 in)
Using strongly contrasting tones and an upright format gives a painting a dramatic message. Used appropriately this is a powerful device.

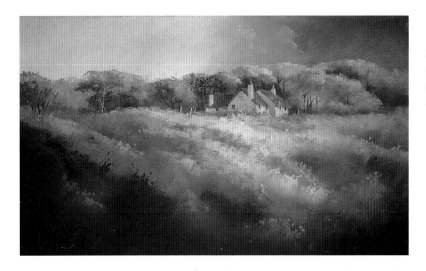

◀ **Sunrise, Brancaster**
18 x 25 cm (7 x 10 in)
Sunrise and sunset are often the best times of day to get good atmospheric effects.

Check out the sky

The sky is the first indicator of mood and atmosphere in a painting. A dark and stormy sky will mean that part of a landscape will be in deep shadow. If you make part of the sky brighter, as though the sun is trying to break through, you have an opportunity to spotlight your focal point, just as though you are in charge of the lights in a theatre. This will make your painting more potent.

A painting full of unremitting gloom can be a bit cheerless so, if you have set a dark and brooding mood, introduce some hope on the horizon. A sliver of light sky coming over a hill will also give you an opportunity to paint a feature, such as a distant silhouette of a farm, in the lighter area.

To describe hard and frozen landscapes, use steely greys contrasted with blistering, vivid oranges. The warm colours will stress the coldness. If you want to depict a rosy dawn,

▶ **Ladies' Climbing Hut, Glencoe**
25 x 36 cm (10 x 14 in)
This scene shows cottages frozen in the grip of winter ice. The warm colours of the grasses enhance the feeling of a steely blue cold day.

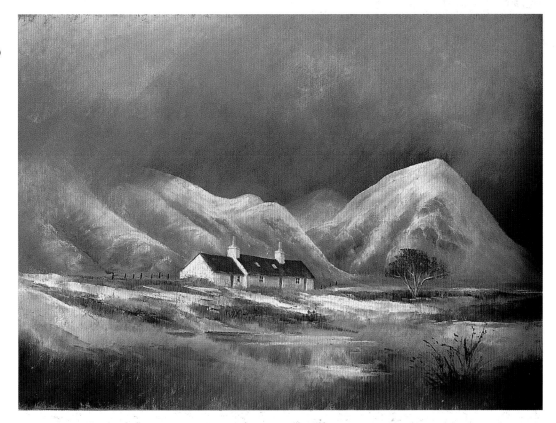

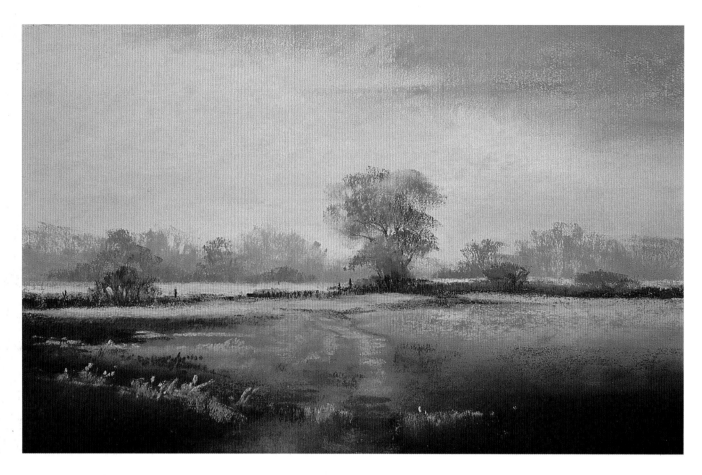

▲ Evening Shadows
18 x 28 cm (7 x 11 in)
Use the atmosphere
and time of day to
create mood. Long
shadows across the
foreground indicate a
sinking sun.

choose all your light tones from the pink and red range. Warm evening light bathes everything in a pink glow, deep shadows emphasize the power of the setting sun and a mood of peace and serenity suffuses the scene.

Muted tones and less contrast will suggest a calm, ethereal feeling in a painting. Avoid using any really dark tones in order to emphasize this mood, and use a horizontal format to add to a sense of calm. Using a limited number of colours in a painting is a good way to set the mood. How about moonlight on water? Using just a dark blue, a soft yellow and white pastel on a dark tinted

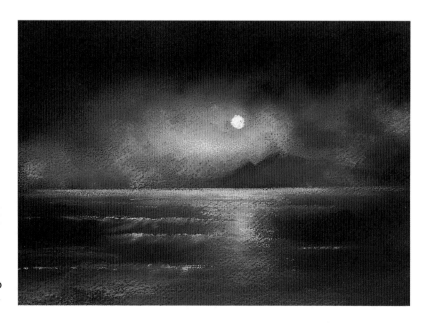

▶ Moonlit Sea
18 x 25 cm (7 x 10 in)
This simple scene was
rendered using only
dark blue, white and
Naples Yellow on Indigo
tinted Canson paper.

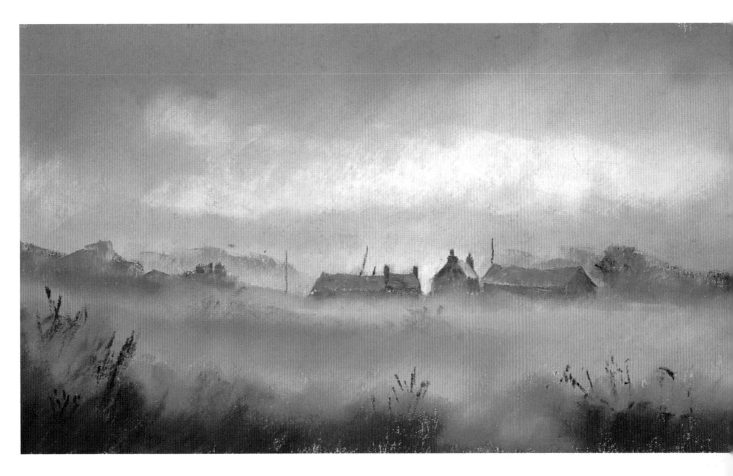

paper takes little work to complete, but evokes a powerful message.

Brighter days

Of course, it is not always doom and gloom. Crisp, frosty winter mornings, when everything looks sparkling and new, and the rich luxuriant colours of spring, summer and autumn, are ideal opportunities to paint bright scenes. Use the colours of the changing seasons and the unlimited range of atmospheric conditions to create your own world in your paintings.

▲ **Rising Mist**
13 x 25 cm (5 x 10 in)
Blending the background and part of the foreground, and leaving just part of the focal point sharp, is an effective way of indicating mist.

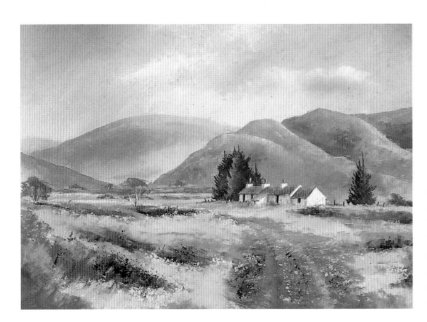

◄ **Cottages near Achnasheen**
25 x 33 cm (10 x 13 in)
To portray the atmosphere of a bright winter day, emphasize the rich colours of dead grasses.

Loch-side Croft House

Pastel is an ideal medium for depicting water because it is easy to blend and you can apply light colours over dark ones effectively. In this painting the reflection of the dark brooding sky helps to emphasize the reflection of the white building. The dramatic skyscapes that haunt mountain regions are also fun to paint in pastel.

▶ First stage

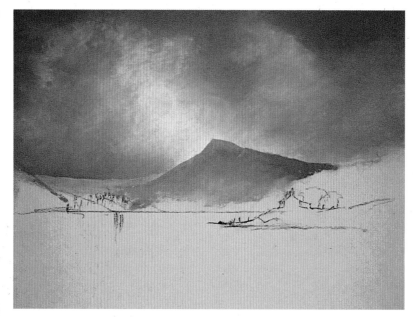

Colours

Lemon Yellow 2

Poppy Red 1

Naples Yellow 0, 2

Raw Sienna 4

Burnt Sienna 4

Burnt Umber 8

Red Grey 2

Purple Brown 4

Purple Grey 2

Unison A34

Blue Grey 2

Silver White

First Stage

On a sheet of cream-coloured abrasive card I sketched out the composition using a sharp charcoal pencil. The sky would dominate the painting, so I spent a little time planning. From my box of pastels I chose the colours for my painting, placing them in a separate foam-lined tray. This little ritual helps to restrict me to a limited palette.

I began blocking in the light area of the sky using Silver White, introducing some Naples Yellow and a little pale pink. This area of pale sky would accentuate the mountain. The darker parts of the sky were blocked in with a combination of Blue Grey and Purple Grey to create interest in the darkest areas of the sky. I blended the whole sky area with my fingers to work the pastel into the grain of the surface, skating some Silver White over the dark areas to hint at cloud movement.

I painted the lower left-hand area of the sky using Blue Grey and Purple Grey to emphasize the far distant sweep of the pass. Using Poppy Red and Purple Brown I made the horizon lighter than the sky. The mountain was painted in using some of the same colours that I used for the sky. This helped to maintain an illusion of recession. A hint of detail on the mountain established the character of the rock.

Second Stage

Using Naples Yellow, Lemon Yellow and Burnt Sienna for the moor, I blended the colours into the lower slopes of the mountain. The fir trees were painted in using Burnt Umber to help them stand out against the lighter background. The light water behind the cottage was drawn in using Blue Grey and Silver White, which provides a contrast to the dark rocks on the promontory.

The white cottage was drawn, using a white pastel pencil for the intricate detail of the chimneys. I stroked in the foliage on the winter birch trees using a pale Red Grey pastel and the branches were drawn in using a white pastel pencil. Burnt Sienna and Raw Sienna provided an underpainting for the area in front of and to the side of the cottage.

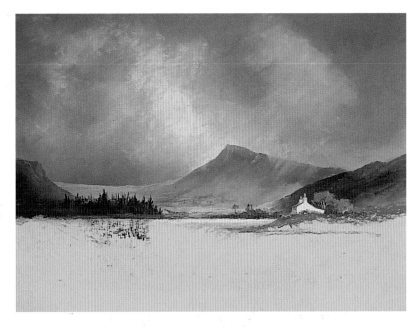

▲ Second stage

Finished Stage

The dark reflection of the fir trees and some of the sky colour were blocked into the water, introducing some warm colour in the centre to reflect the colour of the moor. Using my fingers I blended the reflections in the water with vertical strokes to give the illusion of a glassy surface. The detail of the rocks and dead grasses on the promontory were painted in using a charcoal pencil, followed by the reflections of the promontory and the cottage. Finally, I added a couple of horizontal white ripples using the sharp edge of a white stick of pastel. To suggest movement in the water I made a few horizontal strokes with a chisel-ended colour shaper.

▼ **Loch-side Croft House**
24 x 33 cm (9½ x 13 in)

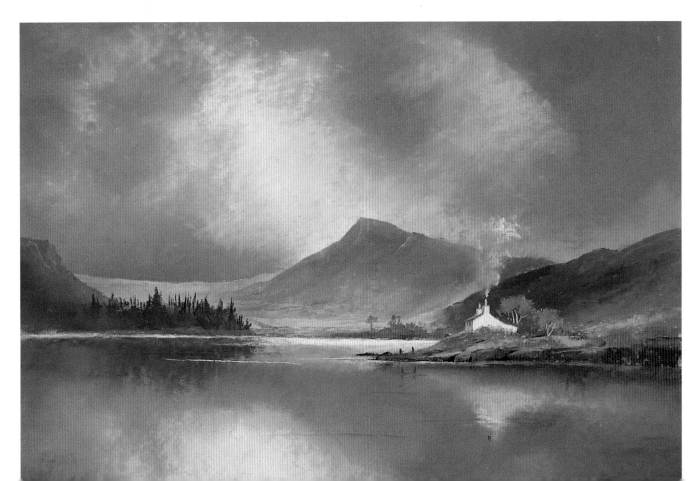

Bluebell Woods

Springtime in a bluebell wood is one of life's finest pleasures. I look forward to the bluebells every year, and planning a visit to the nearby woods has become an annual ritual. The perfume alone is exquisite and the sweeping drifts of blue colour fill me with joy. The challenge is to capture these feelings in a painting.

▶ First stage

Colours

Unison A34

Blue Grey 0, 2

Cobalt Blue 2, 4

Green Grey 1, 4, 6

Unison A45

Burnt Umber 8

Olive Green 5

Sap Green 3, 5

Lizard Green 3

Lemon Yellow 2

Naples Yellow 0

Purple Grey 4

French Ultramarine 6

Mauve 2

Pansy Violet 5

Silver White

First Stage

I chose a sheet of blue-grey abrasive paper for this scene. Using a sharp charcoal pencil I positioned the trees, concentrating on the two in the foreground that framed the view. To create a sense of recession I made the distant trees smaller than those in the foreground. This might seem obvious, but the opposite can be true in a wood; this effect can diminish the illusion of space.

I then indicated the tree shapes that would overlap those visible in the distance. I also thought about where the light and dark areas would be located so that I could hint at

sunlight filtering through the canopy once I began painting.

Using Naples Yellow and Lemon Yellow I hinted at an area of light seen through the distant trees, covering the remaining background with a combination of pale Blue Grey and some pale Sap Green. I blended these colours using my fingers, softening some of the branches so that they would not be too prominent. I drew in some distant tree trunks using a mid Blue Grey, suggesting the distant bluebells using a light Purple Grey, adding some mid Green Grey patches to create shadowed areas.

The tree in the middle distance, which acts as the focal point, was drawn in, overlapping the distant trees. I used two shades of Green Grey to indicate the direction of the light, painting in a dark shadow under the tree using a dark Green Grey, anchoring the tree to the ground; a tree without a shadow can look like it is floating. Some dark Green Grey was used as an underpainting in these shadow areas. I then drew in the fine branches on the focal tree using a sharp charcoal pencil.

Second Stage

More middle-distance trees were painted in behind the right-hand tree in the foreground using Green Grey. Some Sap Green and a few touches of Lemon Yellow were also added to this area. The underpainting for the main area of bluebells was blocked in using a combination of Cobalt Blue, dark Purple Grey and French Ultramarine.

Some of the upper canopy was painted using a dark Green Grey to create a base for the foliage. A base layer of Sap Green was blocked in to create the lower foliage on the right-hand foreground tree. I then decided to make some adjustments to the shadows under the middle-distance trees, having established their relationship with the area adjacent to them.

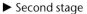
► Second stage

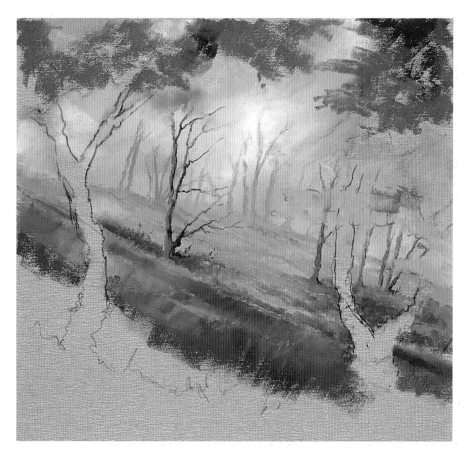

Third Stage

The trunks of the two foreground trees, which frame the scene, were described using dark Olive Green for the shadow side, and pale Sap Green and Lemon Yellow for the sunlit side. I varied the colours to suggest moss and lichen growth, and used the directional light to describe the cylindrical nature of the trunks. Some detail was added to the trunks using a charcoal pencil. Note how the trunks under the foliage are in shadow. Details like this will give your work a more three-dimensional appearance.

I blocked in Cobalt Blue and French Ultramarine to form a base layer for the foreground bluebells, adding some mid Sap Green and Lemon Yellow for the sunlit areas. Dark Green Grey provided a base for the foreground shadow area. Some of the bluebell base layer was blended using a colour shaper and a few dots of Mauve were added to suggest individual blooms.

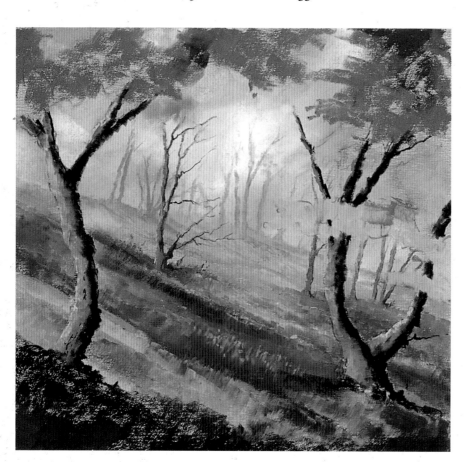

◀ Third stage

▶ Detail showing dotting technique

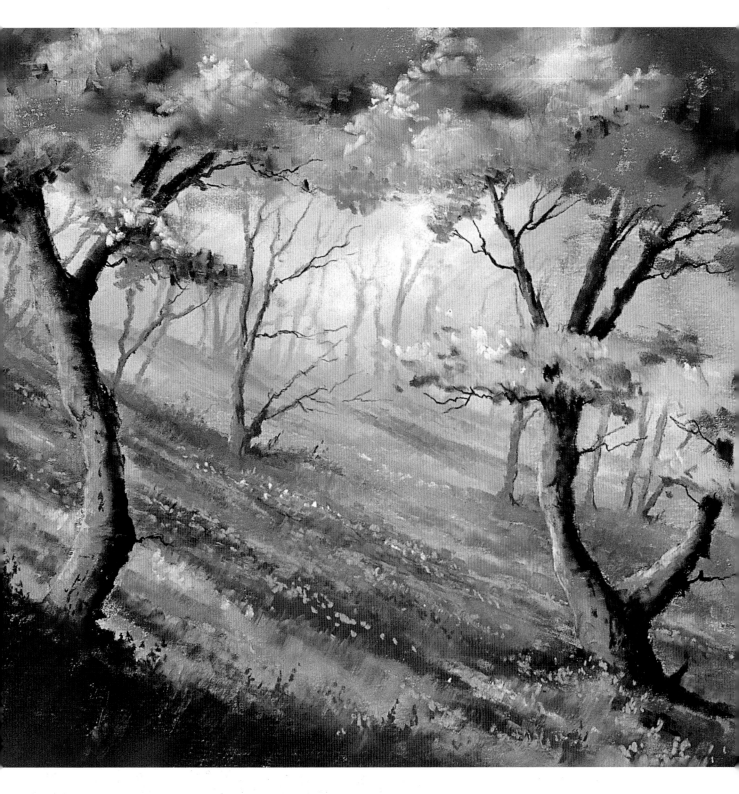

Finished Stage

The tree trunks in the foreground were worked up with a little more detail, and some fine branches were drawn in using the charcoal pencil. More colour was added to the foliage of the canopy, using Lemon Yellow and Sap Green for the sunlit leaves and dark Green Grey for those in shadow. I worked in further dots of Mauve, and a touch of Pansy Violet, into the bluebells. Dark Purple Grey, Mauve and Pansy Violet were used to finish the foreground flowers. Finally, I made a few adjustments to the foreground flowers in shadow using a dark Purple Grey.

▲ **Bluebell Woods**
26 x 25 cm (10½ x 10 in)

Yorkshire Village

The local stone in this village has a warm red-grey background colour, with touches of grey and pale Raw Sienna. However, moss and lichens modify and bring other colours into the buildings. The interesting collection of chimneys on the old buildings on the right, and the sweep of the roof on the central house, draw the eye down towards the figures.

▶ First stage

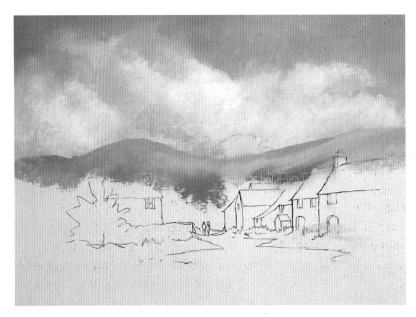

Colours

- Purple Grey 0, 2, 6
- Blue Grey 0, 2
- Cobalt Blue 2, 4
- Red Grey 0, 2, 4
- Green Grey 4, 6
- Sap Green 5
- Raw Umber 3
- Olive Green 5
- Raw Sienna 4
- Lizard Green 3
- Lemon Yellow 2
- Naples Yellow 0
- Poppy Red 1, 6
- Purple Brown 6
- Silver White

First Stage

The outline of the buildings, trees and hills were drawn on cream-coloured abrasive card. There are no particularly difficult perspective problems in this scene, but special attention was paid to the lines of the roof, eaves and the chimneys. I wanted to paint a summer scene, so my colour palette included some bright greens and yellows.

The two figures in this painting are the focal point. Therefore, the buildings must not compete but should provide a frame, or support, to the focal point. There is a lot of detail and it is important to consider how to manage the various elements. The two figures were placed heading down the lane to suggest that there is something around the corner, making the stroll worthwhile. I use this type of narrative to draw viewers into the picture.

To suggest a summer's day I decided to paint a simple sky with scudding clouds. The main colours of pale Blue Grey, Cobalt Blue and pale Purple Grey were blocked in to create the top half of the sky. Naples Yellow, a hint of pale Poppy Red and Silver White were used to form the lower part of the sky. I began blending these together to form soft edges, and to work the pastel into the surface. A few touches of white were added to the sky to represent the light catching the clouds.

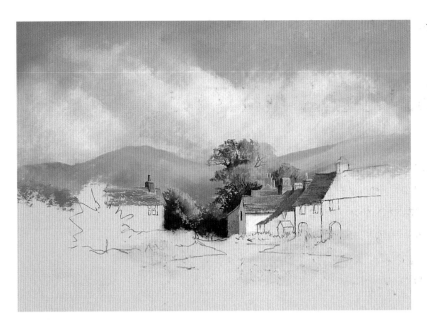

I brought down the sky over the line of the hills to prevent a line appearing along the hilltops and to make the sky look as though it continues behind the hills.

The hills were painted using pale tints of Blue Grey. Sap Green was used for the areas bathed in sunlight, adding a slight hint of Red Grey to create interest. I used a variety of colours in the background hills as a substitute for detail, and to help maintain a sense of recession. A mid shade of Blue Grey was used in the lower part of the central hills to provide a contrast for the light side of the small tree in the lane that was painted a pale Lizard Green.

Second Stage

The trees in the lane were painted using Olive Green and dark Purple Grey for the shadow side. These trees provide a dark area of contrast for the main focal point, i.e. the figures. Over to the right, more distant trees provide a backdrop for the chimneys. I kept the contrast less intense here so that it does not draw the eye away from the focal point.

The chimneys and roofs were painted using a variety of Red Greys, introducing some pale Lizard Green and Poppy Red to represent mosses and lichens. I used a chisel-ended colour shaper to achieve sharp lines, and sharp charcoal and pastel pencils to render the fiddly bits of stonework. The wall on the central building, caught in the full sun, was painted using Silver White, and the end wall that is in shadow with the lightest tint of Blue Grey. The window was drawn in with a charcoal pencil.

Third Stage

I spent some time finishing off the buildings, paying attention to the play of light and shade. I used pastel and charcoal pencils for the detail around the windows and doors. I then worked on the front gardens, foreground trees and grass using Lemon Yellow, Lizard Green and Olive Green. To create the road I used Blue Grey and Red Grey. I utilized the dark areas to emphasize the light, sunlit regions.

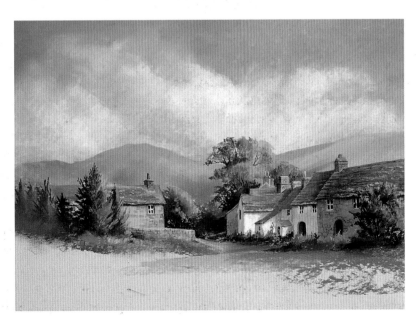

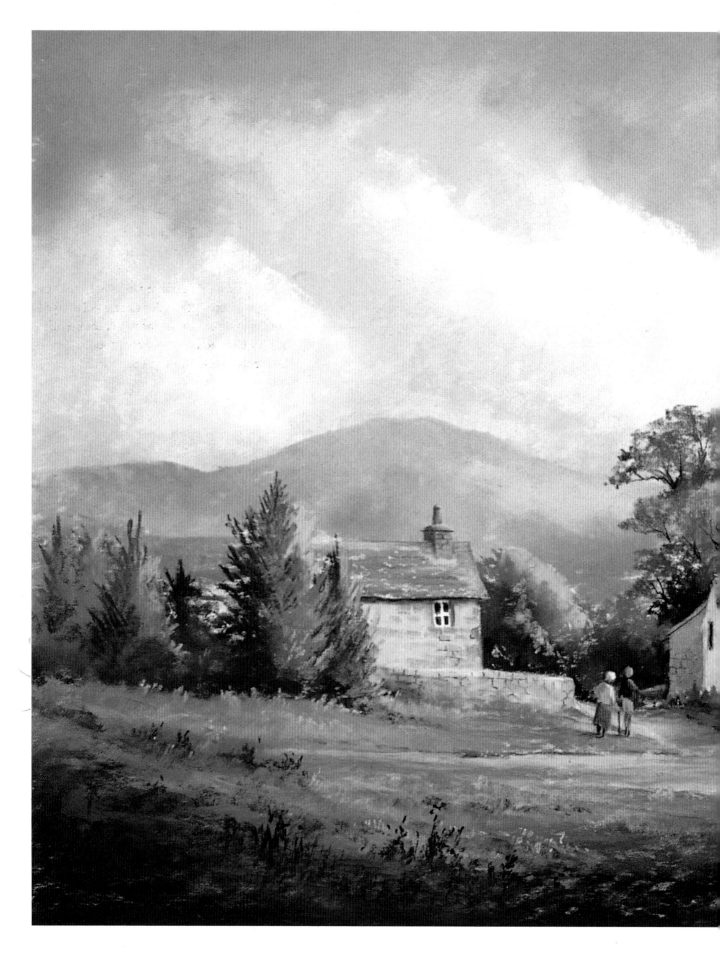

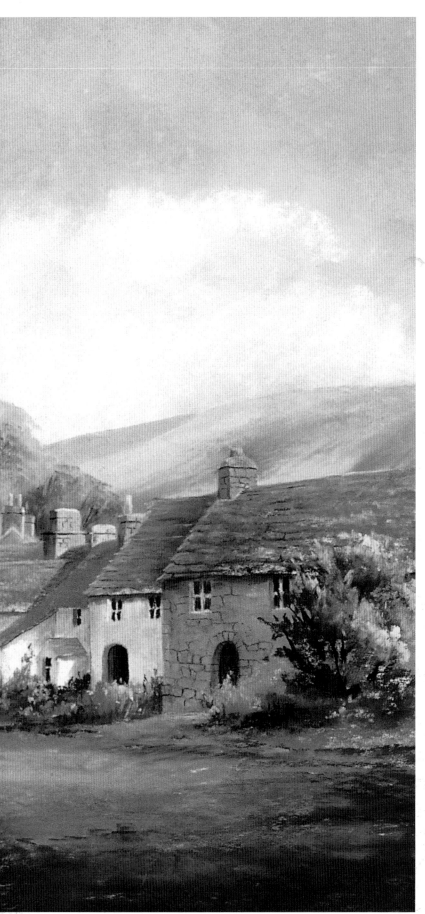

Finished Stage

At this stage I took some time to consider where to position the figures. Looking at my original plan, I decided to bring them slightly closer to the edge of the green, making one figure elderly and the other one young. The old lady is wearing drab colours and the young girl is clothed in bright red, which acts as a complementary colour to the green behind her.

I softened the kerbs and lines of the road so that they were not too dominant and merged them into the grass in places, sweeping dark Purple Grey across the foreground to concentrate attention on the figures.

▼ Detail from finished painting

Exmoor Cottage

This scene describes an autumn evening. The sun is sinking fast, just catching the vibrant colours on the tops of the trees and casting long shadows through the woods. There is a slight nip in the air despite the warm colours on the trees. The apples have been harvested from the orchard and winter is approaching.

▶ First stage

Colours

Purple Grey 0, 2, 6

Blue Grey 0, 2, 4

Burnt Umber 8

Red Grey 0, 4, 6

Green Grey 4, 6

Sap Green 5

Burnt Sienna 4

Indian Red 2

Poppy Red 1, 6

Olive Green 5

Raw Sienna 4

Lemon Yellow 2

Raw Sienna 1, 4

Naples Yellow 0

Silver White

First Stage

I drew in the main shapes on a sheet of buff-coloured abrasive card. This part of Exmoor is situated in a belt of old red sandstone, giving rich reds and a warm pink glow to the local stone. Round chimneys, rough stonework and half-hipped roofs are also common features in this particular region. The exuberant colours of autumn provided me with an opportunity to use all the luscious hues we are often denied in landscape painting. However, a combination of warm-coloured buildings and trees does present a challenge. This problem can be overcome by using complementary colours and a good tonal range. I had a lot of fun planning the colour palette.

The simple sky was blocked in using various tints of Blue Grey and Purple Grey for the dark areas, and pale tints of Red Grey, pale Poppy Red and Silver White for the lightest parts. I planned to use counterchange on the background hill, so I painted a hint of light using pale Blue Grey on the horizon above the left-hand side of the hill. I blended the colours together and worked them into the grain, bringing the sky down over the line of the hill.

◄ Second stage

Second Stage

The hill in the distance was painted in, making it light against a dark sky on the right and dark against a light sky on the left to indicate the direction of the light. I used the direction of the pastel strokes to describe the contours of the hill. Mid tones of Blue Grey and Red Grey were used to create the shadow area. Where the light was hitting the hill, I added pale tints of Poppy Red and Green Grey.

The distant trees were stroked in using the side of a pale Blue Grey pastel to describe the shape of the canopy. I kept the colours cool against the light side of the hill and began to introduce some warm light colours against its shadow side. This helps to reinforce the direction of the light. I introduced some mist, using pale Blue Grey, to the gap between the buildings to simplify the detail.

Third Stage

The buildings were painted in using Red Greys. I gave the distant cottage a simple treatment so that it would not compete with the cottage on the right – the focal point. Great care was taken to accurately represent the local character of the buildings. Some Olive Green was introduced onto the roof to suggest moss and lichen. I then painted in the trees to the right of the main building using dark Purple Grey to provide a good contrast for the detail of the cottage.

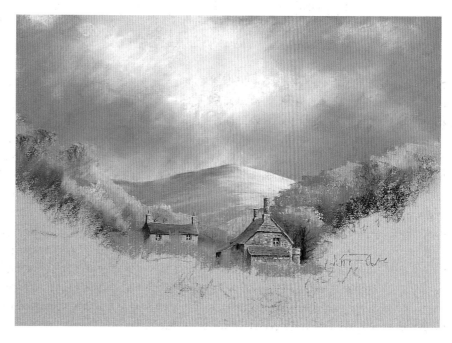

► Third stage

Finished Stage

I enjoyed painting the vivid colour on the trees to the right of the main cottage, using complementary colours of yellow and purple to emphasize the power of the evening sun. The shadow side of the foliage was described using a middle tint of Burnt Sienna. The remaining trees and undergrowth were treated loosely, hinting at an overgrown garden with a rickety shed in the right-hand corner.

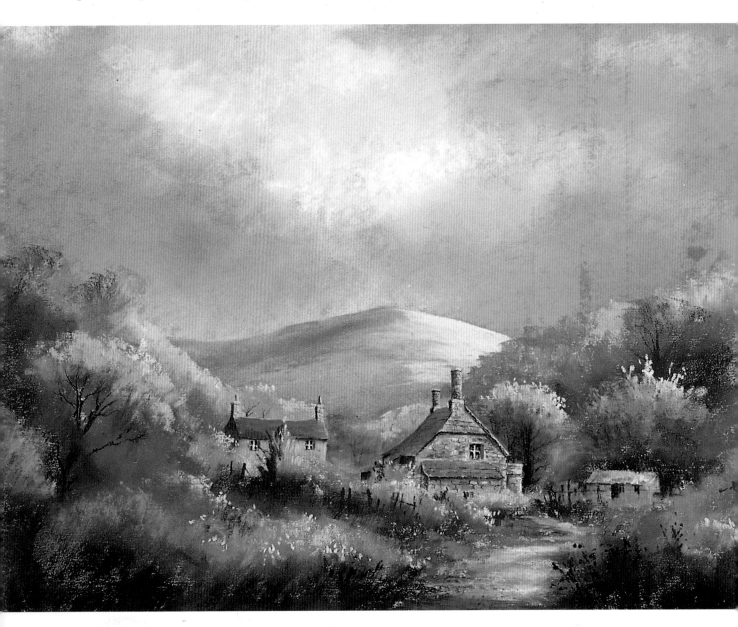

▲ **Exmoor Cottage**
25 x 36 cm (10 x 14 in)

A Final Word

Don't let the fear of failure, or a perceived absence of early progress, prevent you from having fun with pastel painting and drawing. If you decided to learn to play a musical instrument, you would start with simple tunes and expect to spend a lot of time practising. Approach learning to draw and paint in the same way, and you will succeed.